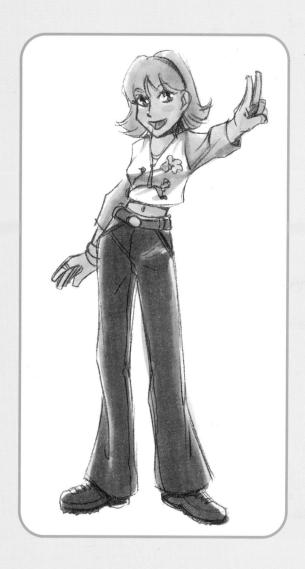

MANGA SECRETS

Lea Hernandez

IMPACT

CINCINNATI, OHIO

www.Impact-Books.com

About the Author

Lea Hernandez is the 2004 Lulu award winner as editor of the ground-breaking webcomics site www.GirlAMatic.com. She is also the multiple-Eisner nominated creator of *Rumble Girls* and *Rumble Girls: Runway Lightning Ohmry* (NBM), *Killer Princesses* (with Gail Simone, Oni Press), the acclaimed Texas Steampunk graphic novels *Cathedral Child*, *Clockwork Angels* and *Ironclad Petal* (Cyberosia), and artist of *The Hardy Boys* (Papercutz/NBM). She is the re-writer of *Oh! My Goddess*, *What's Michael*, and *3x3 Eyes* for Dark Horse Comics. Lea is also a long-time manga retouch artist, logging over 5,000 pages. Notable previous credits include guest lecturing at Minneapolis College of Art and Design and the Savannah College of Art and Design, Marvel Mangaverse *Punisher* with writer Peter (SUPERGIRL) David, *Transmetropolitan* #33 and *Transmetropolitan: I Hate It Here* (DC Comics), contributor to GT Labs' *Dignifying Science*, cover artist for *The Anime Companion*, the anime and manga column for *Wizard* magazine, and artist for various Disney comics. Lea was a vice-president in the legendary animation studio GAINAX (*Evangelion*, *Furi-Kuri*) and Nebula-recommended short fiction author. Lea lives in Texas with her husband and kids, dogs, cats, and rats.

Acknowledgments

Christina Xenos, Wendy Dunning and Pam Wissman of IMPACT Books, for bringing *Manga Secrets* from proposal to completion. Maggie Thompson, for recommending me for the job. Sum, for posing for reference. Lisa Jonte, Carla Speed McNeil, Adam Warren, Toren Smith, Joey Manley, the GirlAMatic.com girls and guys, the Tarts, the Lulus, Shon Howell, David Okum, Susie Lee, the members of First Unitarian Universalist Church of San Antonio, the Bodensteiners, Jane Irwin, Dan and Katie Merritt, APE, Rick and Deborah Geary, Anime Iowa, and the Anime Iowa boys for all being very much like themselves and a part of my life. My LiveJournal regulars who made a pleasant anchor in the vacuum of making a book. Ex nihilo nihil fit.

Special thanks to dad and mom for getting me a new digital camera.

Metric Conversion Chart

To convert	to	multiply by
Inches	Centimeters	2.54
Centimeters	Inches	0.4
Feet	Centimeters	30.5
Centimeters	Feet	0.03
Yards	Meters	0.9
Meters	Yards	1.1
Sq. Inches	Sq. Centimeters	6.45
Sq. Centimeters	Sq. Inches	0.16
Sq. Feet	Sq. Meters	0.09
Sq. Meters	Sq. Feet	10.8
Sq. Yards	Sq. Meters	0.8
Sq. Meters	Sq. Yards	1.2
Pounds	Kilograms	0.45
Kilograms	Pounds	2.2
Ounces	Grams	28.3
Grams	Ounces	0.035

Other fine IMPACT books are available from your local bookstore, art supply store or direct from the publisher.

09 08 07 06 05 5 4 3 2 1

Library of Congress Cataloging in Publication Data
Hernandez, Lea.
 Manga secrets / Lea Hernandez.
 p. cm
 Includes index.
 ISBN 1-58180-572-1 (pbk. : alk. paper)
 1. Comic books, strips, etc.—Japan—Technique. 2. Drawing—Technique. I. Title.

NC1764.5.J3H47 2005
741.5—dc22 2004056684

Edited by Christina Xenos
Designed by Wendy Dunning
Production art by Lisa Holstein
Production coordinated by Mark Griffin

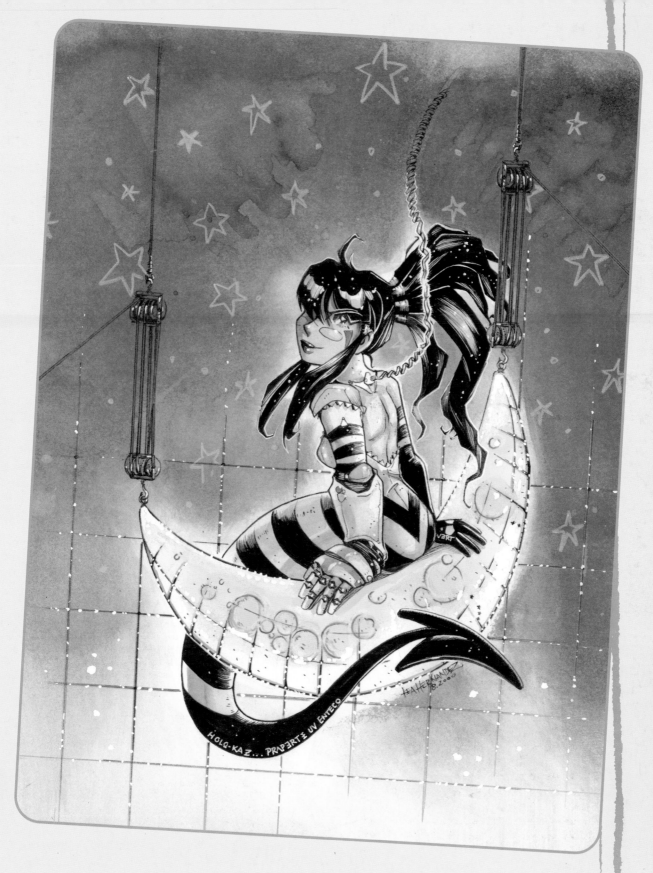

Dedication

For Christina Xenos, who brought out the best in
this book—Gutta cavat lapidem.
For King, Invincible Sum, and Strangel—Non mihi,
non tibi, sed nobis.

Table of Contents

[1]
Manga Features
10

Draw faces, expressions and elements of the manga body.

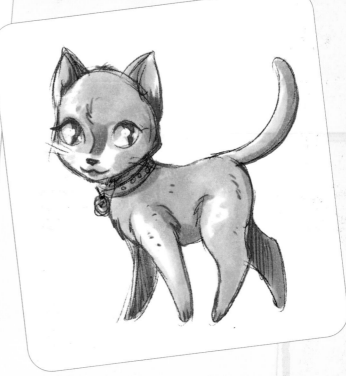

I didn't decide to "draw manga" because it was "hot."

I am not in love with the outermost layers of anime and manga,

or in drawing it only for message boards—never really telling a story.

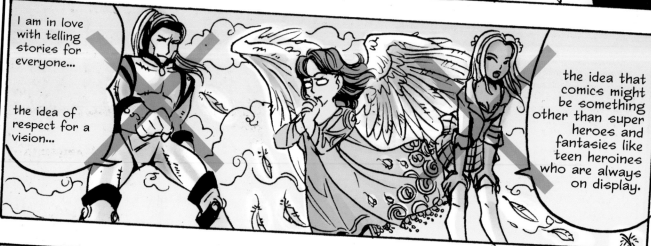

I am in love with telling stories for everyone...

the idea of respect for a vision...

the idea that comics might be something other than super heroes and fantasies like teen heroines who are always on display.

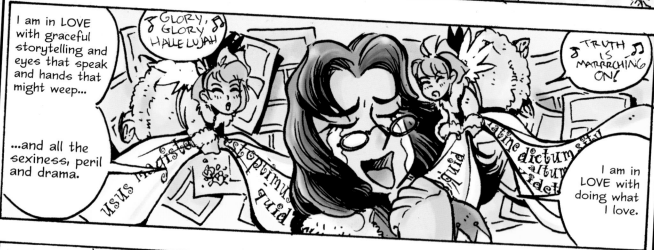

I am in LOVE with graceful storytelling and eyes that speak and hands that might weep...

...and all the sexiness, peril and drama.

♪ GLORY, GLORY HALLELUJAH ♪

♪ TRUTH IS MARRRCHING ON! ♪

I am in LOVE with doing what I love.

To put it another way:

You're reading this book because you want to know about manga-style drawing techniques.

Maybe because you just want to know more about a style and manner of story-telling and cartooning that's become popular and recognized all over the world,

but also maybe because, like Lea, it moves you in a way no other style does.

Manga's got a lot of ideas, fun, beauty and energy, and you'll get more respect for that influence if your craft is good! Contemporary manga has a surprising origin, too...

Manga as we know it today started about fifty years ago with one man: Dr. Tezuka Osamu. Also known as kami no manga (the god of comics) and "the Walt Disney of Japan," he created the comic *Shintakarajima (New Treasure Island)*, based on Robert Louis Stevenson's *Treasure Island*, in 1947. It was an instant hit.

Tezuka eventually created 150,000 pages of comics, 500 stories and 21 TV series.

Until Tezuka, manga was mainly read by children, but since, manga is read by everyone in Japan. What we see the most of over here in translations is influenced strongly by what anime catches on here.

Tezuka's company, Mushi (bug) Productions, produced both the first animated TV series in Japan and the first color animated series: *Tetsuwan Atom (Astro Boy)* in 1963 and *Jungle Taitei (Kimba, the White Lion)* in 1965.

He pioneered reusing expressions and poses, making animation both faster and less expensive to make.

It's just big eyes and speed lines!

Those big eyes came from Disney, and many stylistic devices of manga and anime can now be found in a lot of American shows and comics!

I'm not crazy about Disney, but I love manga.

Tezuka was strongly influenced by Disney's works: he saw *Bambi* 80 times, and *Snow White* 120 times!

Even though modern manga proceeds directly from Tezuka, there are many other artists in both anime and manga who were and are influential. You owe it to yourself to discover them!

To get you started, some excellent books on manga and anime are listed on page 111.

There are waaaay too many websites to even start to list them, but an index of websites about everything anime and manga is www.anipike.com.

You can also do a basic Internet search. I like using www.google.com, with "manga" and "anime" as key words!

Now, on to the drawing!

Before You Begin

Now that you know how manga began, here are some more specific tidbits on manga language and materials that will help you throughout the book.

Manga Language

ANIME (AH-nee-may)—the Japanese word for animation, also used to denote animation from Japan.

BISHONEN (bee-SHO-nen)—cute and/or beautiful boy.

BISHOJO (bee-SHO-jo)—cute and/or beautiful girl.

CHIBI (CHEE-bee)—a short character with a large head and small body. Also "Chibi-(name)": a chibi version of a character.

GOTHIC LOLITA—the Japanese take on the goth style of dress and lifestyle. Kind of like if aliens from the Cute Dimension invented it.

MANGA (MAHN-gah)—the Japanese word for "comics," also used to denote comics from Japan.

MANGA-KA (MAHN-gah-ka)—a notable manga creator. It's not appropriate to call oneself a manga-ka.

ONESAMA (oh-NEE-sama)—big sister, or a way a younger girl addresses an older girl she admires.

SAILOR UNIFORM—a sailor-style uniform (white shirt with a large square collar in back). Uniforms for school are common in Japan; many young characters in manga and anime wear them. The best-known manga and anime that was built on sailor uniform is (what else) *Sailor Moon*.

SHOJO (SHO-jo)—manga for girls.

SHONEN (SHO-nen)—manga for boys.

Splash Page
A single-panel page that can be found anywhere in a comic story, but is usually found at the beginning. The splash page usually has the title of the story or installment; in most Western comics, it will also have the names of the artist, writer, colorist, letterer and editor. But this was at the end of a story so I used it like a freeze-frame to bring that part of the story full stop.

Open panel Word balloon Thought balloon

Comic Page

Panel Gutter Panel border Caption Sound effect

Materials

You don't need a lot to start making your own manga, but here are my recommendations for the materials you will need to make the best use of this book.

Paper

- Wirebound sketchpads for practice, with 50- to 70-lb. (105gsm to 150gsm) paper. Copy paper for layouts.

- Use 80- to 100-lb (170gsm to 210gsm) paper in a "smooth" finish for your final work.

Drawing Tools

- You can use any pencil, your like. Try a mechanical pencil with 5mm or 7mm lead, a side lead advance and a fat barrel to keep your hand from cramping.

- Red and black Prismacolor pencils are great for their fat, energetic line, but keep a sharpener close by.

- "Click" erasers and white plastic erasers.

Inking Tools

- Sharpie markers.

- Marks-a-Lot markers.

- Zig Millennium Pens, sizes 005 to 8. These pens are far superior in price and performance.

- Faber-Castell Pitt Brush Artist Pens.

- Copic Brush Markers and Multiliners are becoming easier to find, cost about the same as Faber-Castell pens and are from Japan.

- Correction pens. My correction tool of choice is Pentel's Presto! Easier Squeeze correction pen.

Other Materials

- C-Thru clear plastic grid ruler, with a metal cutting edge.

- French curves are a must for drawing curved areas and curved motion or speed lines. Try C-Thru's KT-8 three-piece set, which features top and bottom inking edges. Cheaper curves are thin and break easily and usually don't have an inking edge.

- A lightbox, or a window with a strong light or daylight on the other side of it for seeing and correcting your drawing from the back of the paper.

In manga, stories can be about action or relationships, even when those stories are also science fiction, fantasy, or real-life drama.

Both kinds have something in common: people. All sorts of people—young and old, pretty and ugly, heroes and villains. When you observe real people you'll see these types!

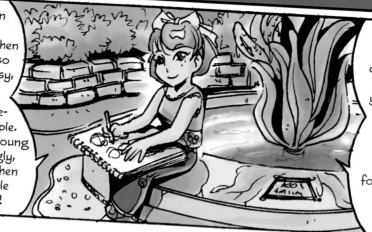

If you can, take a class in life drawing, which is drawing from live models with a teacher to help you see and understand.

You can also watch, study and draw people anytime and anywhere for free. This section will give you the basics of drawing people.

You'll start with basic facial features...

...like mouths, eyes, and ears.

Next, some finer details like hair...

Then we'll combine those features into heads.

You'll learn about proportions and how they vary...

...from person to person.

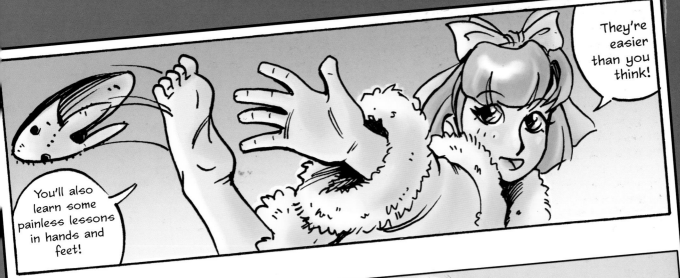

They're easier than you think!

You'll also learn some painless lessons in hands and feet!

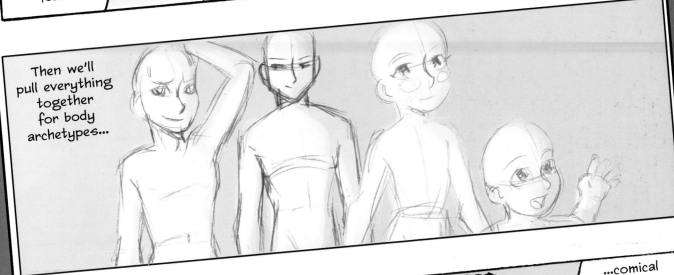

Then we'll pull everything together for body archetypes...

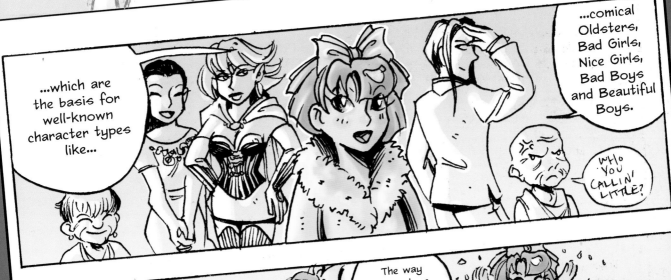

...which are the basis for well-known character types like...

...comical Oldsters, Bad Girls, Nice Girls, Bad Boys and Beautiful Boys.

WHO YOU CALLIN' LITTLE?

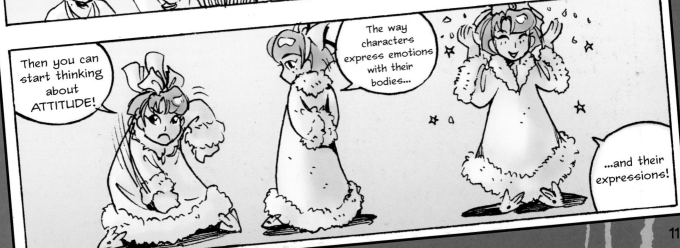

Then you can start thinking about ATTITUDE!

The way characters express emotions with their bodies...

...and their expressions!

Expressive Eyes

Let's start with the first thing many people notice about manga, the eyes! While not all manga is that "big-eyed stuff," a lot of what has been seen in the West is, and the eyes are certainly one of the most attractive things about Japanese comic art. Eyes in manga can span from meticulously-rendered to mere dots and lines. Generally they're understood to be large, appealing, expressive and gorgeous.

Use Eyes to Show Expression
Eyes can show what someone is feeling and thinking even when you can't see the rest of the face. The shape of the eyelids, brow bone and eyebrows make each eye different.

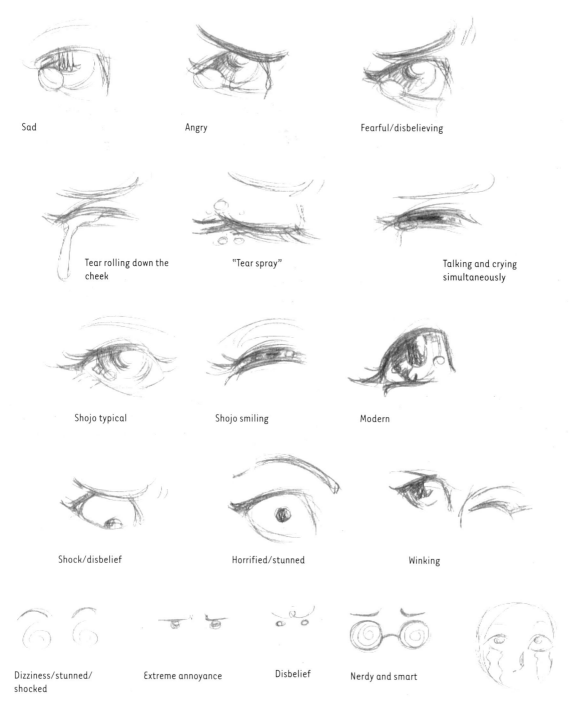

Sad

Angry

Fearful/disbelieving

Tear rolling down the cheek

"Tear spray"

Talking and crying simultaneously

Shojo typical

Shojo smiling

Modern

Shock/disbelief

Horrified/stunned

Winking

Dizziness/stunned/shocked

Extreme annoyance

Disbelief

Nerdy and smart

Exaggerated rivers of tears

Drawing Manga Eyes

Now that you've seen some examples of manga eyes, follow these steps to create eyes of your own.

Designing the Eye Shape

The round eyeball is the underlying eye structure. Create a circle bigger than you want your eye to be. You don't have to draw that every time you create an eye, but if you ever find yourself with eyes that just don't look right, see if you've remembered to be on the ball. Next draw a closed lid.

Highlight Shapes

In shojo manga, highlights are not just round, but also diamond shaped, and there are a lot of them!

 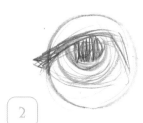 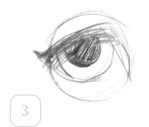 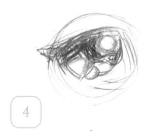

1 2 3 4

1 Draw the Lids

Open the closed eye by adding a thick line where you will place eyelashes to the top eyelid.

2 Place the Iris and Pupil

Place another circle in the eyeball for the iris—the colored part of the eye. Its location reveals where your character is looking. The size of the iris also says a lot about who you're drawing: larger is prettier; smaller can show fear or shiftiness of character. Draw the pupil inside the iris. The size of the pupil in manga doesn't often correspond with its actual function: getting larger or smaller in response to light. Instead, pupils usually change in response to a character's situation.

3 Add the Shadow

Shade the pupil to show the shadow of the upper eyelid. This tiny touch effortlessly makes your eyes more 3-D and believable.

4 Highlight the Eye

Highlights on a manga eyeball are generally placed for effect. I like for at least one highlight to fall about halfway across both the upper and lower iris, and another highlight to bridge the white of the eye and the iris.

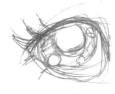

Heavy Highlights

Notice that the pupil in this Sailor Girl eye is pretty much one big highlight. Watch out, a highlight can affect where a character appears to be looking.

Simplifying Mouths

The mouth in manga is tied with the eyes for the "most eloquent facial feature." Technically, it is pretty much a line that defines where the lips meet, or a line that defines the opening of the lips.

Let's see how mouths are constructed by looking at realistic drawings, which progress to cartoon drawings. After sketching a bunch of expressions, I laid another piece of paper over them and simplified what I had done. The red lines are the lines I eliminated.

Side View

It is very hard to draw a realistic side view that doesn't look overdone. In the simplified version, I went for the profile of the lips and the line where they meet—a very common design solution.

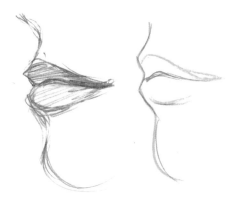

Stick Out That Tongue

Not much difference in the realistic and simple versions.

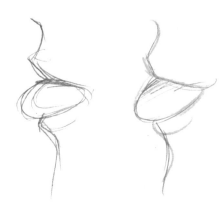

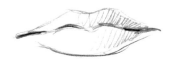 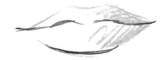

Front View

In the simple version, notice the line where the lips meet is the line that makes the expression.

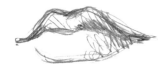 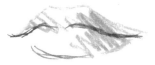

3/4 View

This view destroys artists because they fail to understand that perspective affects faces! The receding side of the lip gets shorter and a bit rounder.

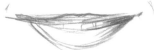 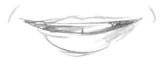

Smile With Teeth

A very common mistake is trying to draw every tooth. If you look at your own teeth, you see that they're not like piano keys in your mouth. In the simplified version, I took away the lip rendering and used the inside edges of the open lips to make the expression.

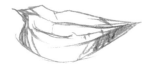 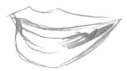

3/4 Grin

Note the light rendering of the teeth. In the cartoony grin, I went for an exaggerated canine tooth.

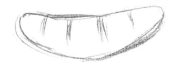

Toon Grin

A very cartoony version of a closed-teeth grin. The teeth are simple vertical lines in the mouth shape. This grin is associated with avarice and insincerity.

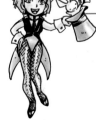

Mouth Hazards

Although manga mouths are pretty easy to draw, two things usually trip up beginners and pros alike:

Attempting to draw every little line : Even in more realistic art styles (like these examples), I didn't go for photorealism.

Correctly placing the mouth on the face : I'll show you how to do that on page 17.

14

Use a Mirror

Studying your mouth in a mirror will help you get your mouths right. (No one has to know you make funny faces.) Be sure to use a fairly strong light, so you can see the shapes of the mouth easier.

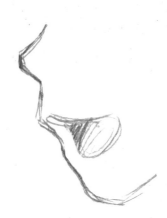

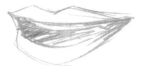

Open Mouth Smile, 3/4 View

In more of a laughing smile, the upper lip is stretched back, revealing teeth. The more someone smiles, opens their mouth, or both, the thinner the lips get as the facial muscles stretch them. The simplified smile is very cartoony. I curved the upper lip down.

Open Mouth Profile

You can see the upper teeth, the tongue, and a bit of the inside of the mouth. Notice how cartoony the simplified view is: it exaggerates the profile of the open mouth by putting a mouth shape inside it.

Full Lips

These lips pretty much say "sexy." Keep in mind that rendering lips in cartooning tends to make characters look more feminine—something used to great effect on pretty boy characters in bishonen manga.

Kid Mouth

On younger characters, a simpler mouth helps give a visual cue of age.

 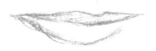

Detailing Lips

Darker lips in black and white art will read as lipstick, which is often the province of the bad girl.

Yelling/Yawning, 3/4 View

This really demonstrates the stretching and thinning of the lips, and shows off the tongue and teeth. In the simplified version, I made the mouth longer from top to bottom, and narrower from side to side.

 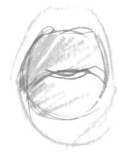

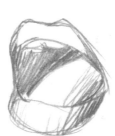 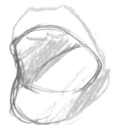

Open, Front View

In the realistic view, the whole shape is like an "O." In the cartoony version, I only used the inner edges of the lips, and the shape is the "O" on its side. The teeth may or may not be visible.

Open, 3/4 View

Look how the "O" is indented on the receding side in both versions. Also remember to add the curving line showing the tongue!

Morphing Ears

Ears are a tangle of complicated curves within a simple, tilted egg shape. They are like hair in that you don't draw every line. There's something strange about a character who only has one line for a mouth, but every line in his ear detailed! You can get away with fairly simple ears in manga. Here are some things to keep in mind so your ears are in harmony with the other features on your characters. Just like with the mouths, I created a realistic view and then show the lines I took out in color.

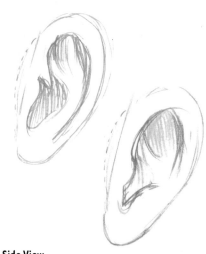

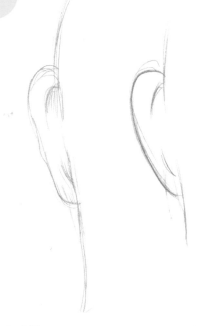

Side View
The ear is a classic egg shape formed with the smaller end pointing down; the larger end of the "egg" is tilting back.

Back View
You don't see this view very often, except on characters who are bald or have very short hair. However, this view is easy to draw, and there's little difference between realistic and cartoony. The shape resembles half of a heart.

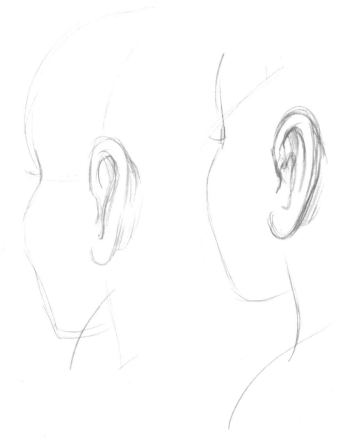

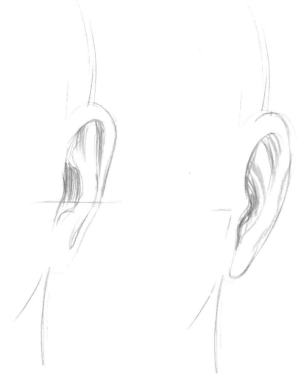

3/4 Back View
This is one of those views that is extremely hard to get right, and even when it is right, it still looks a little wrong. The basic egg shape in this view is squashed to a thin oval. Although the simple view isn't perfectly anatomically correct, it "looks" right.

Front View
It's a common mistake to draw ears in front views the same as in side views. From this angle, you see all the parts, but the structures of the ear flatten and overlap—unless someone has ears that naturally stick out more.

Creating a Head, Front View

Drawing a head from a front view is less challenging in terms of perspective, but more challenging because there's less room to hide quirks like uneven features. Take heart, though—your face isn't perfectly symmetrical either. Take a straight-on photo of anyone, cut it in half, and mirror the halves, you'll see the differences.

Vary Your Heads

Faces usually start with an egg shape, because it approximates the cranium, jawline and chin so well. Try designing and drawing faces starting with other shapes like squares, long ovals, circles and triangles. And, of course, look at real people, and take note of any pleasingly unusual faces. Draw them, or photograph them if you have permission.

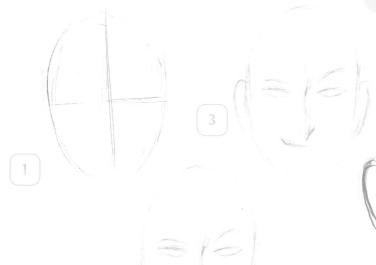

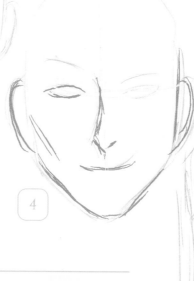

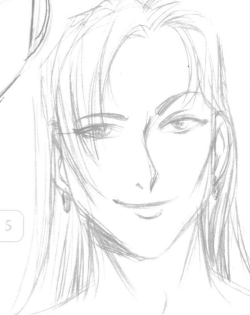

1 Use an Egg for the Face
Start with an egg shape. Don't worry about it being perfect. Divide the egg with two lines: one halfway through the shape horizontally for the eye and ear placement, one halfway through the shape vertically for the nose and mouth placement.

2 Add the Eyes and Nose
Rough in the eyes and nose. I've chosen to draw an adult Beautiful Boy, so his eyes are long and narrow, and placed slightly above the eye line. His eyebrow placement depends on his expression. For now, I'm drawing him with a bemused lift to his right eyebrow. His nose is long and slender. It starts at the inner corners of the eyes and ends halfway between the eyes and chin.

3 Draw the Mouth and Ears
He has a long mouth. Usually, a mouth is about halfway between the bottom of the nose and the point of the chin—his is a little higher to make him look haughty and mature, and he's smirking. His ears start at his eye line, and ends at his mouth line with his earlobe.

4 The Flip Side
Flip your drawing over and look at it on a light table, in a mirror, or against a window. My corrections are in red. Correct yours on the back, then turn it over and erase where you corrected. Use the marks on the back as a guide for redrawing the erased parts. If it doesn't turn out exactly right, just keep drawing, and flipping until it does. I squared up this jaw, and added lines to suggest facial definition

5 Finishing Details
Once you've drawn the head and placed the features, go for the finish! Finish your character's eyes, ears, and mouth, and give him some hair. On masculine male characters, go easy on eyelashes, since eyelashes in comic art read as feminine.

Creating a Head, 3/4 View

Now that you've learned how to draw the front view, try drawing the head at an angle.

Don't Just Copy— Study!

The face is one of the places where manga anatomy is at its most elective. Although copying what you see helps you learn, learning how to draw only by copying manga and anime is like playing the game of telephone—where a group takes turns telling each other something in a whisper to find out how different the message is at the end of the game—with your drawing. Even my own works have weaknesses I'd hate for someone to learn to duplicate.

Learn the map of the face, then you're free to cartoon it! If you just copy someone else's map without question, you'll be lost a long time.

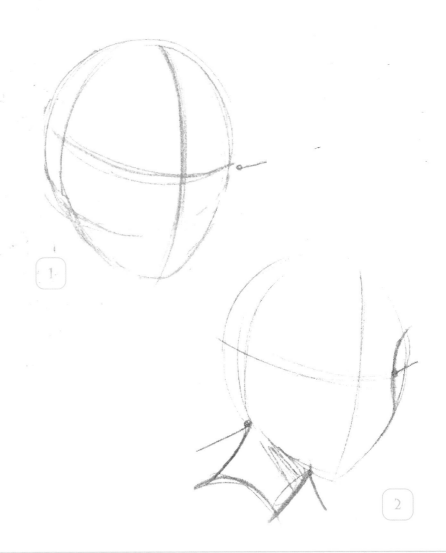

1

2

1 Basic Shape and Construction Lines

Start with a ball intersected by an egg. The ball is the back of the skull; it's dome shaped. The egg makes the side of the head, chin and jaw. Draw a horizontal curved line about halfway down the face for eye placement. Use the back vertical curved line to position the ear—the edge of the egg you already drew. Draw a vertical curved line in the front to place the mouth and nose.

2 Rough In Basic Structure

The spot between your browbone and cheekbone is the small curved line on the right. Add the line for the back of the neck. Here, I moved it a bit forward to make the character look cuter. The front line of the neck is two-thirds of the way between the ear/jaw line and the nose/mouth line. Add a shadow under the jaw. The jaw is softer and more curved for female characters, and straighter in male characters.

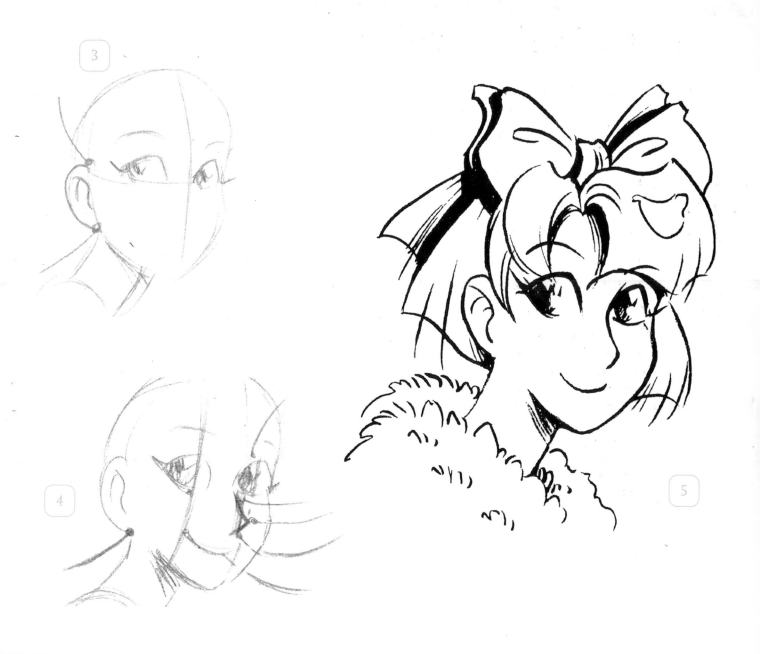

3 Add the Eyes and Ears

Add the eyes to the head, but first look at yourself in a mirror. Notice the symmetry of your eyes from the front. As you turn your head, you'll notice that the far eye looks smaller and more distorted than the near eye. A little bit of this face's near eye falls slightly below the eye line, but most of it is above. The eyebrows are curved lines above the eyes. Notice how the far eyebrow is shorter and a bit lower.

The ear is a nice "C" shape that falls between the intersection of the eye/ear line and the ear/jaw line.

4 Form the Nose and Mouth

A typical manga nose is a checkmark that describes the side of a nose without the nostril. The easiest way to get a good nose shape is to draw a curved checkmark backwards from the inside of far eye. This checkmark slightly crosses the nose line.

Draw the mouth as a curve that starts where the bottom of the ear would intersect the middle of the eye. The corners of an adult mouth are in line with the pupils. The younger someone is, the smaller his mouth. Babies' mouths are only as wide as the space between their eyes.

5 Finish the Face

I decided this was yet another drawing of Nan, and added her hair, bow, and the collar of her chenille robe. If you vary eye size, hair, and expression, you'll come up with someone else. Experiment with making facial features further apart than usual, lower or higher, or closer. Also try placing them on a more round, less round, or even square head shape.

Hairstyles

Most people have thousands of hairs on their head, but you don't have to draw every single one! You don't see hair as individual strands, you see it as shapes. Even artists who choose to render hair with lots of lines still treat hair as overall shapes.

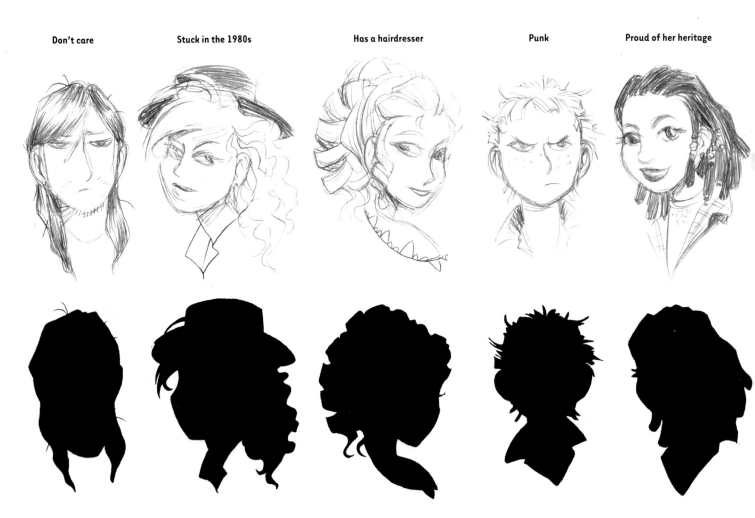

Don't care **Stuck in the 1980s** **Has a hairdresser** **Punk** **Proud of her heritage**

Notice Silhouettes
Aside from faces, hair is one of the most individual and revealing characteristics about people. The shape of a character's hairstyle can help you recognize them, even in silhouette.

Drawing Hair

Now that we've looked at some hairstyles, let's take the lady who has a hairdresser, and practice drawing her hair. You'll see that even her fancy 'do can be broken down into shapes.

1 Sketch the Basic Shapes of the Hair

Remember that anyone with hair also has a skull! This elegant lady has a pretty poofy style, so the basic shapes of her hair are going to be much larger than her skull, unlike the Punk and Don't care boy, who both have hair that more closely follows the shape of their skulls. Loosely sketch the shapes of her hair to plan where everything is going.

2 Refine to Show Mass and Head Shape

Start sketching lines to indicate the spirals of her curls, how her hair falls back from her forehead, and how it sweeps up on the sides. Remember, these lines need to curve, showing not only mass but also that her poofy hair is influenced by the shape of the skull under it.

3 Render to Show Light and Depth

Carefully erase your construction lines from step 1. Add rendering to give her hair a little more depth and to indicate where light is striking it. Use light strokes to shade the insides of her curls. Add lines to emphasize the curves on the outside of the curls, her upsweep and bangs. Leave the curls on the far side of her head the way they are; the lack of shading makes those curls recede and adds depth.

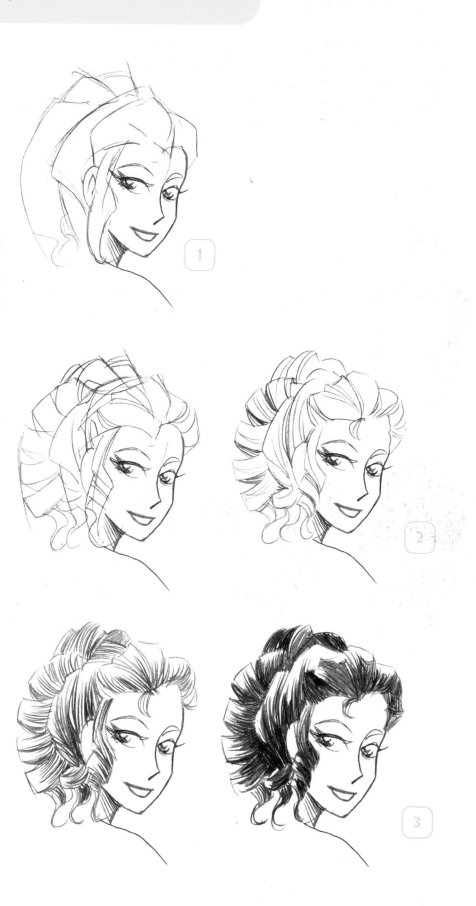

Baby Heads

A baby's head is round, with the features in the lower part of the face. The skull is big, the jaw and chin are soft, and the eyes are large. Babies have short necks and round shoulders that aren't much wider than their heads. In manga and anime, characters with this head structure read as "cute." A lot of mascot and sidekick characters have these proportions, too.

The relation of eyes, ears, mouth and nose on a head are fairly consistent across ages and genders. The biggest difference between babies and adults is the shape of the head and where the features are on the head, not the features themselves.

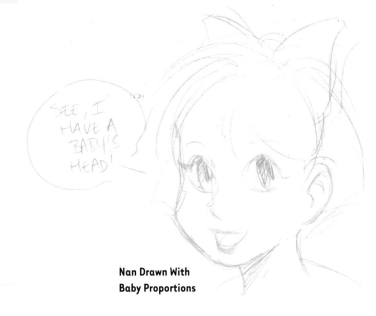

Nan Drawn With Baby Proportions

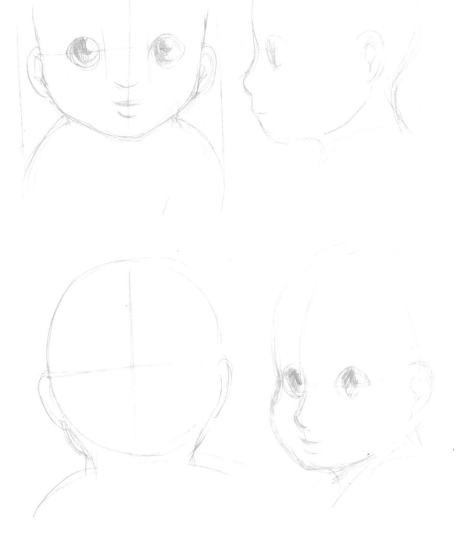

Child Heads

A child's head is still baby-round and soft, but the features are higher on the face than a baby's head. The neck is getting longer and slimmer, and the shoulders are still round, but they're getting wider.

This boy and girl were drawn using exactly the same head to make a point: Girls and boys look pretty much alike when they're young, and the only thing that separates "boy" from "girl" in preschool to third grade are haircuts and clothes.

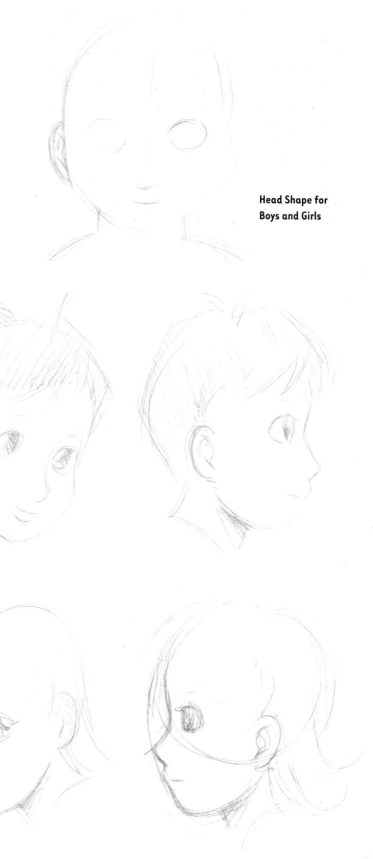

Head Shape for Boys and Girls

Boy Head

Girl Head

23

Teen Heads

A tween/teen's face is losing the "baby fat" and acquiring adult lines. The shoulders are even wider and beginning to get adult definition. Keep girls looking young by making their eyes big. At this age, a boy's Adam's apple begins to become prominent. His eyes will be smaller, comparatively, than a girl character of the same age.

Teen Boy Head

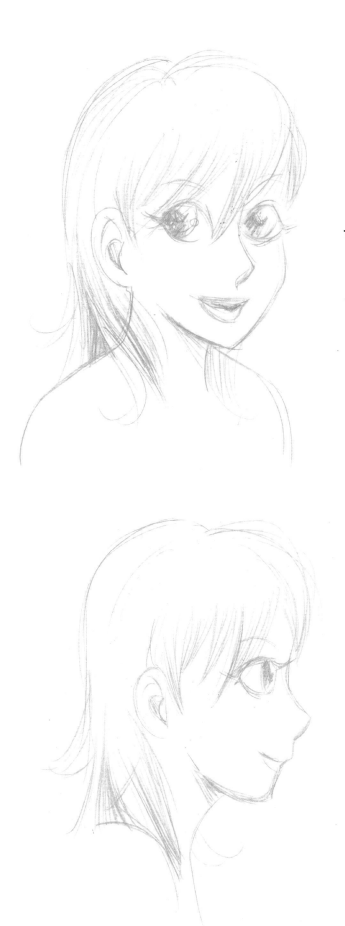

Teen Girl Head

Adult Heads

An adult's face has eyes halfway down the head. The shoulders are 2 heads across, and the neck, shoulders and jaw are well-defined.

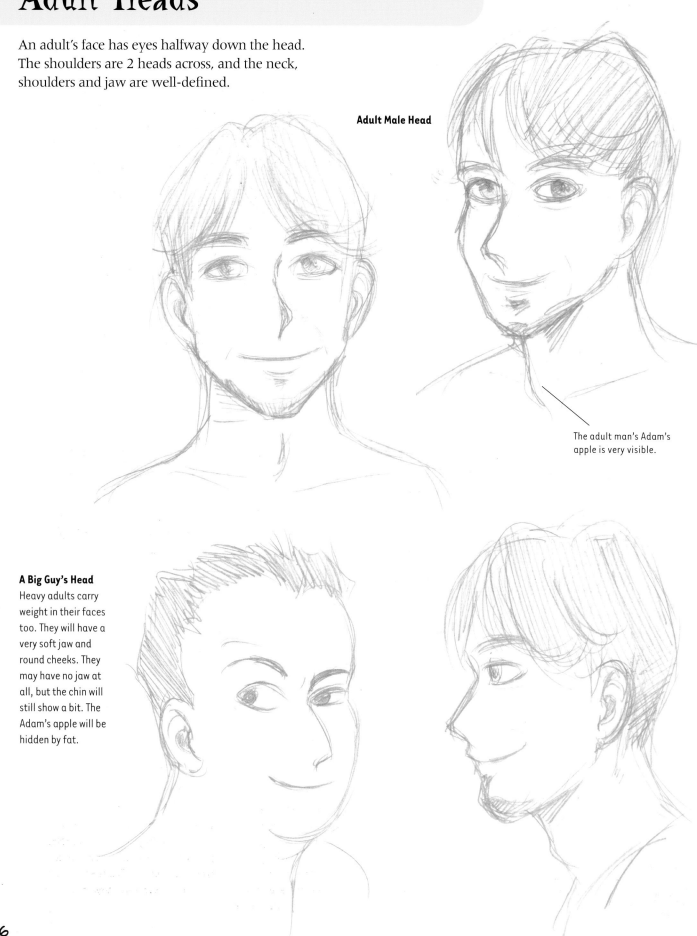

Adult Male Head

The adult man's Adam's apple is very visible.

A Big Guy's Head
Heavy adults carry weight in their faces too. They will have a very soft jaw and round cheeks. They may have no jaw at all, but the chin will still show a bit. The Adam's apple will be hidden by fat.

Adult Female Head

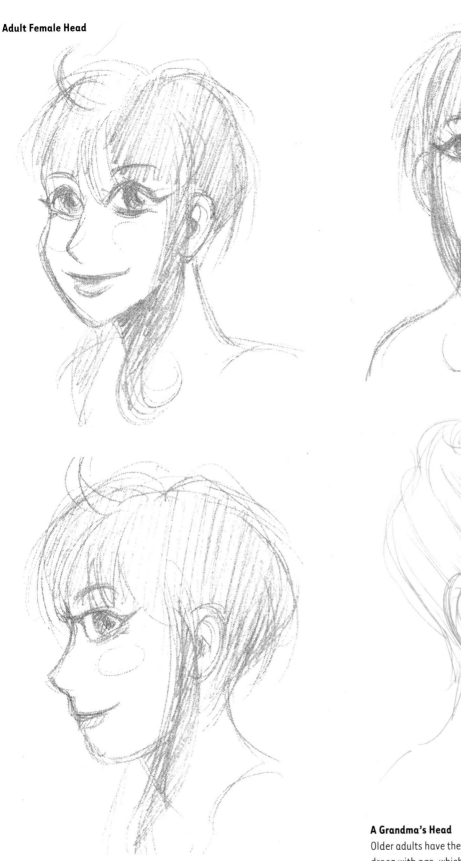

In manga, a mature woman's eyes are smaller and sleeker since the biggest eyes are associated with youth.

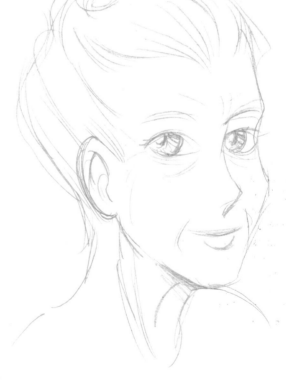

A Grandma's Head

Older adults have the same facial map, but the skin begins to droop with age, which softens the jaw. They're acquiring wrinkles from laughing or frowning. A character who's lived a very hard or interesting life will have lots of experience lines. This is where looking at real people is great because older people are carrying their life stories in their face!

An Array of Expressions

Here's Nan modeling thirty of her favorite expressions. I heartily recommend studying manga to see how other artists solve expression problems and how they convey emotions in both realistic and comedic ways. I've drawn these based on expressions I've used, made up, seen in anime, drawn from studying my own face, seen in shojo manga, and so on. Try combining different eyes and mouths, and see what the new face "says" to you. There are infinite possibilities!

Take the time to draw yourself and others to not only add to your repertoire of expressions, but also to better understand how others invented theirs.

Where Do Expressions Come From?

Almost any cartooned expression, even the ultracartoony, is a based on a real expression. For example, eyes as one wide "X" (opposite page) is an abstraction of eyes and eyebrows knitted together in annoyance. Eyes that are dots paired with a tilted line for a mouth (this page) indicate dumbfoundedness and surprise, like the way eyes widen and the mouth goes slack when someone is presented with something they can't quite cope with.

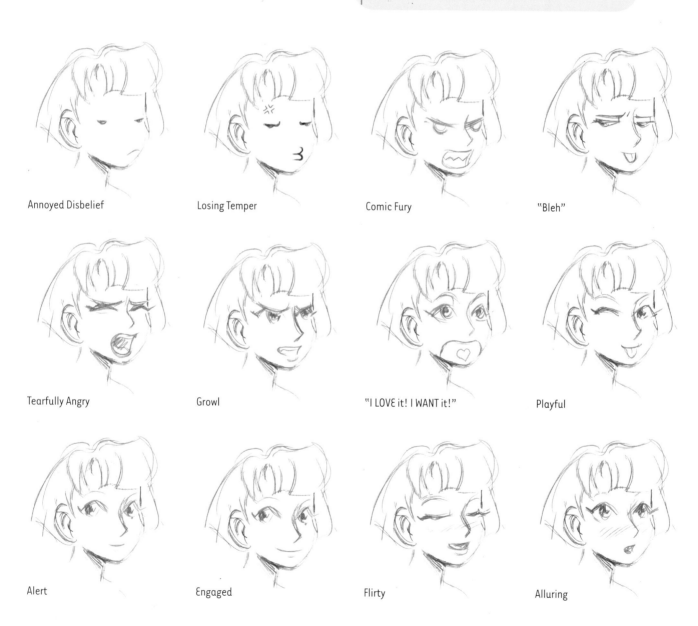

Annoyed Disbelief

Losing Temper

Comic Fury

"Bleh"

Tearfully Angry

Growl

"I LOVE it! I WANT it!"

Playful

Alert

Engaged

Flirty

Alluring

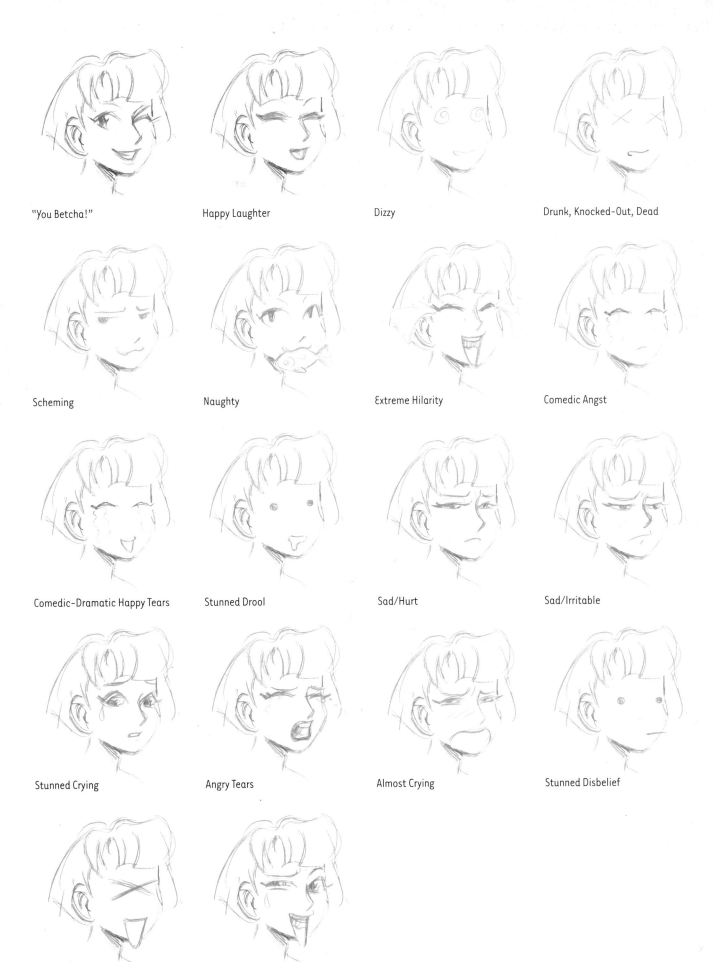

"You Betcha!"

Happy Laughter

Dizzy

Drunk, Knocked-Out, Dead

Scheming

Naughty

Extreme Hilarity

Comedic Angst

Comedic-Dramatic Happy Tears

Stunned Drool

Sad/Hurt

Sad/Irritable

Stunned Crying

Angry Tears

Almost Crying

Stunned Disbelief

"D'OH!"

Jaw-Drop Embarrassed

Drawing Hands

Why are hands so hard to draw, never mind draw well? Here three reasons:

1. You haven't practiced enough.
2. There are twenty-seven bones in it!
3. Hands also twist, curl, grab, drop, point, pick, and gesture in an almost infinite number of ways.

This complexity gives them expression matched only by the face. Manga artists make great use of this expressiveness.

Use your hand for reference. Look at how your knuckles are placed to understand proportions from finger to finger. Generally, the top knuckle on the pinkie lines up with the middle knuckle on the ring finger, and the pinkie fingertip lines up with the top knuckle of the ring finger. The thumb tip (when the fingers are spread) falls along the imaginary curved line that defines the middle knuckle placement of all the fingers.

Use a Drumstick

Lea's best trick for drawing hands is to think of the thumb like a drumstick on a fan with four ribs. Sounds goofy, but it works.

1 Sketch Your Structure
First, draw four fanned lines, connected at the bottom with an oval.

2 Add the Thumb, or "Drumstick"
Place the fat end of the drumstick at the wrist line. Note that the thin end of the drumstick meets the curved line for the middle knuckle placement.

3 Indicate the Knuckles
Add the lines that indicate placement for the top and bottom knuckles.

4 Flesh Out the Back of the Hand
Outline the back of the hand and thumb. Look at how the thumb, has a triangle of webbing when it's extended. Keeping the drumstick under the structure keeps your thumbs where they are supposed to go and your hands constructed well!

5 Add the Final Details
Flesh out the fingers, adding lines to indicate the knuckles and fingernails. Lighter lines suggest youth and/or femininity; heavier lines suggest age, scarring, or hard work.

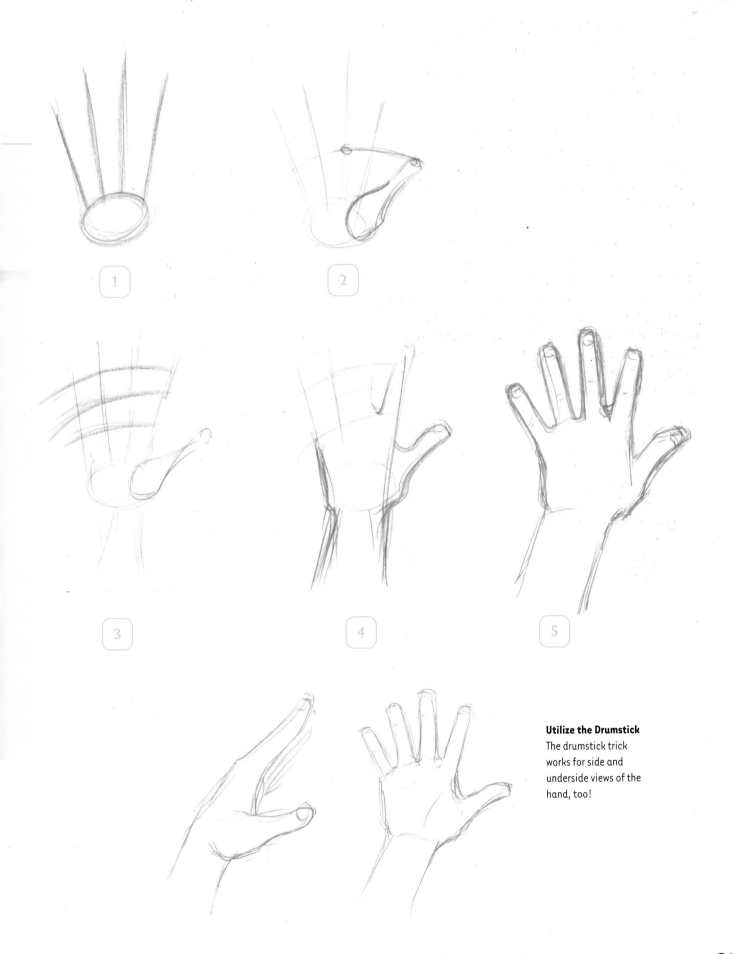

Utilize the Drumstick
The drumstick trick works for side and underside views of the hand, too!

Drawing Feet

Feet, like hands, have a heel, a fan of five digits, and a bunch of bones. Depending on the angle, some areas of the foot are visible and some aren't. These next examples show feet from just about every possible angle. I've sketched a small rough and a complete drawing so you can see how to construct them.

Don't Be Intimidated

Feet aren't nearly as hard to draw as hands, but artists still have a hard time with them! They try to avoid them by drawing everyone wearing long robes, skirts and pants, or placing them in water or in a land of giant props. Sooner or later, your characters will want to wear shorts, step out from behind the giant top hat, or get out of the water, and stand on their own two feet.

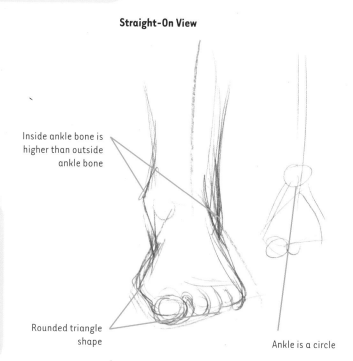

Straight-On View

Inside ankle bone is higher than outside ankle bone

Rounded triangle shape

Ankle is a circle

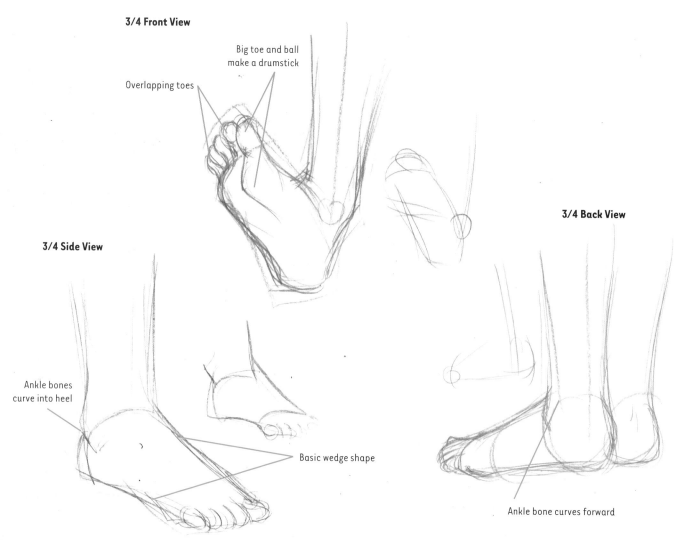

3/4 Front View

Big toe and ball make a drumstick

Overlapping toes

3/4 Side View

Ankle bones curve into heel

Basic wedge shape

3/4 Back View

Ankle bone curves forward

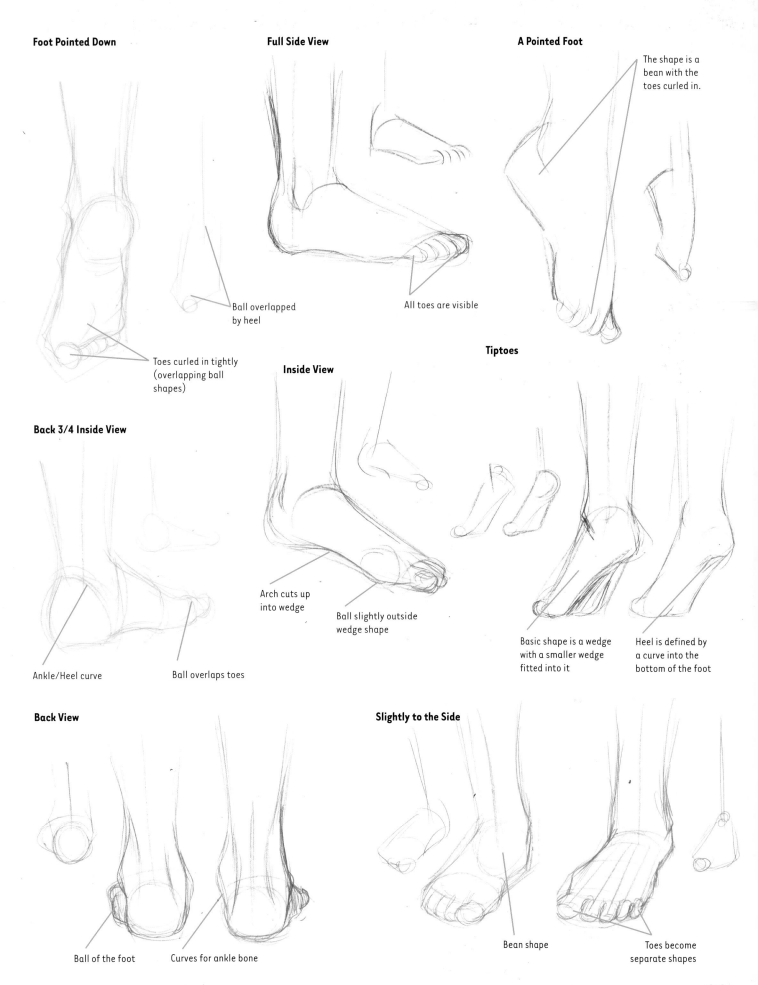

Foot Pointed Down

Ball overlapped by heel

Toes curled in tightly (overlapping ball shapes)

Full Side View

All toes are visible

A Pointed Foot

The shape is a bean with the toes curled in.

Back 3/4 Inside View

Ankle/Heel curve

Ball overlaps toes

Inside View

Arch cuts up into wedge

Ball slightly outside wedge shape

Tiptoes

Basic shape is a wedge with a smaller wedge fitted into it

Heel is defined by a curve into the bottom of the foot

Back View

Ball of the foot

Curves for ankle bone

Slightly to the Side

Bean shape

Toes become separate shapes

33

When you're costuming your characters in period garb, special gear like a spacesuit, or a specific costume like a samurai, use reference photographs as much as possible. Eyewitness books and catalog reprints are excellent for this. You can also find photographs of period clothing on the Internet. I like the image search on www.google.com.

Many artists keep files of pictures clipped from magazines for costume reference. This let's you study folds and draping of different kinds of clothing and fabrics. You can also get examples of shoes and accessories. Fashion magazines are inexpensive, and full of pictures of all sorts of clothes and accessories, great for drawing very stylish characters, and even futuristic ones. Most high fashion looks like it comes from outer space, anyway!

But don't copy a photograph from a magazine or the Internet! Photos are protected by copyright law. Many famous people also guard the use of their likenesses. It's also a courtesy to your fellow artists to not swipe their photos or drawings. People will totally judge you if they see you're a swiper, and not in a good way!
Swiping is never okay. It's stealing. Now let's look at some character types, both good and bad!

There are many archetypes in anime and manga. You see them over and over again because they're popular and easily identifiable. There's a difference between easily identifiable and plain played out, though! Some of these are...

SCHOOLGIRLS and SPACESUITS!

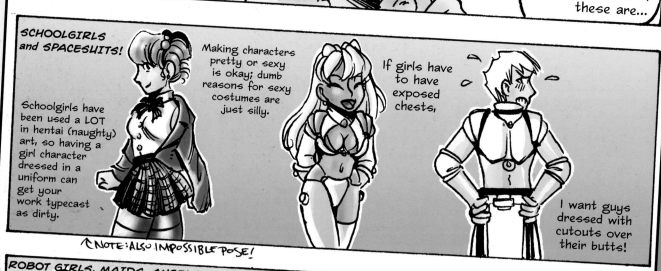

Schoolgirls have been used a LOT in hentai (naughty) art, so having a girl character dressed in a uniform can get your work typecast as dirty.

Making characters pretty or sexy is okay; dumb reasons for sexy costumes are just silly.

If girls have to have exposed chests,

I want guys dressed with cutouts over their butts!

↖ NOTE: ALSO IMPOSSIBLE POSE!

ROBOT GIRLS, MAIDS, ANGELS and ANGSTY BOYS!

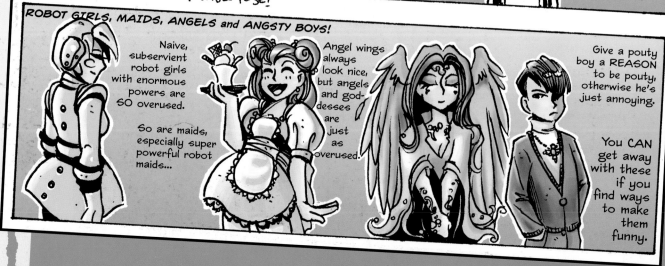

Naive, subservient robot girls with enormous powers are SO overused.

So are maids, especially super powerful robot maids...

Angel wings always look nice, but angels and goddesses are just as overused.

Give a pouty boy a REASON to be pouty, otherwise he's just annoying.

You CAN get away with these if you find ways to make them funny.

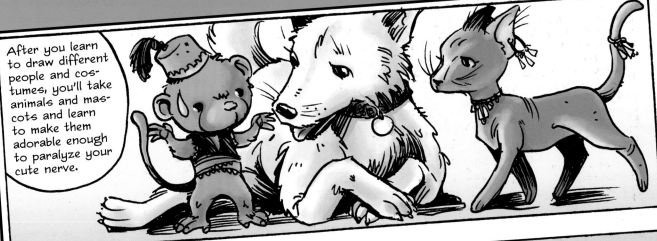

After you learn to draw different people and costumes, you'll take animals and mascots and learn to make them adorable enough to paralyze your cute nerve.

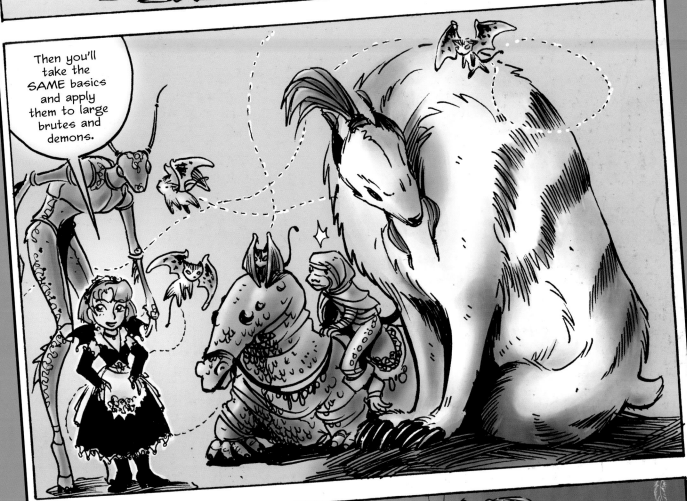

Then you'll take the SAME basics and apply them to large brutes and demons.

Once you're finished with this section, the sky's the limit on what kinds of animals you can draw...

...and what sort of weird critters you can design!

Archetype Proportions

How body parts relate in proportion to each other gives you very distinct character body types. When you are drawing your characters, always begin by sketching the shapes of the head and torso, then add lines to show the positions of the arms and legs. This helps make your characters consistent. Even experienced artists use these shapes and lines to show gesture and proportion. It's also easier to check and correct anatomy at this stage, rather than erasing parts of a lovely finished work.

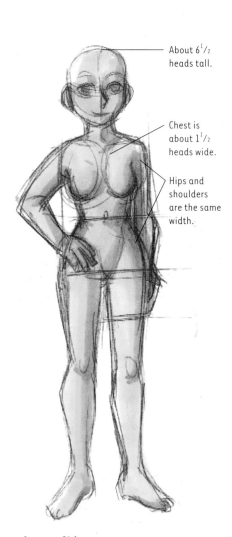

About $6^1/_2$ heads tall.

Chest is about $1^1/_2$ heads wide.

Hips and shoulders are the same width.

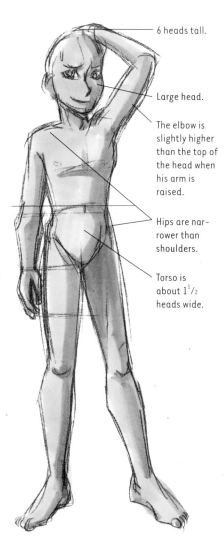

6 heads tall.

Large head.

The elbow is slightly higher than the top of the head when his arm is raised.

Hips are narrower than shoulders.

Torso is about $1^1/_2$ heads wide.

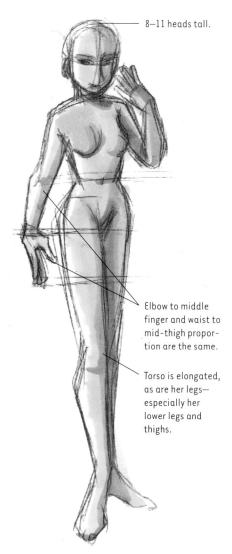

8–11 heads tall.

Elbow to middle finger and waist to mid-thigh proportion are the same.

Torso is elongated, as are her legs—especially her lower legs and thighs.

Average Girl

This body belongs to the Nice Girl, Sweetheart and Girlfriend in shonen manga. With slight variations in her hips and bust, she's also the Tomboy, the Bad Girl, and the Sexy Girl. You'll see girls with these proportions in fantasy, sci-fi, and drama comics.

Average Guy

The Average Guy represents guys from their early teens to twenties. He is the basis for characters like the Nice Guy and the Nerd in shonen and shojo manga. With a slightly smaller head, Average Guy becomes even more average, bridging the gap in proportion between him and Shojo Guy.

Shojo Woman

Keep this gal willowy and graceful because she's the Heroine, Princess and Big Sister! This gal is fabulously all leg. This very leggy build in the West resembles a fashion illustration.

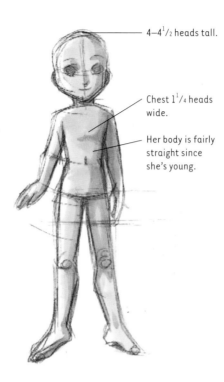

4–4$\frac{1}{2}$ heads tall.

Chest 1$\frac{1}{4}$ heads wide.

Her body is fairly straight since she's young.

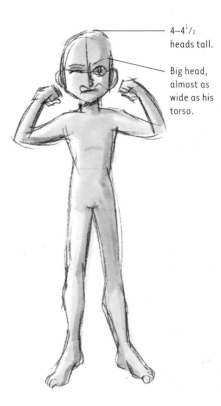

4–4$\frac{1}{2}$ heads tall.

Big head, almost as wide as his torso.

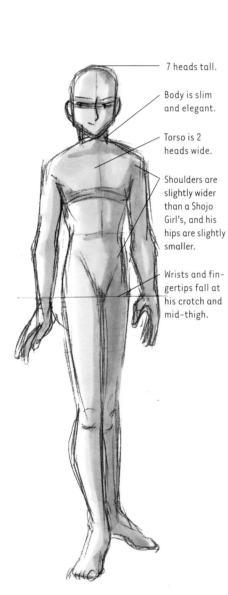

7 heads tall.

Body is slim and elegant.

Torso is 2 heads wide.

Shoulders are slightly wider than a Shojo Girl's, and his hips are slightly smaller.

Wrists and fingertips fall at his crotch and mid-thigh.

Little Girl

This girl is the heroine of manga meant for young girls.

Little Guy

The Little Guy is anywhere from six to eleven years old. Although boys and girls are shaped pretty much the same until nine or so, I still drew his shoulders a little wider to make him look more boyish.

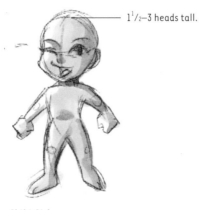

1$\frac{1}{2}$–3 heads tall.

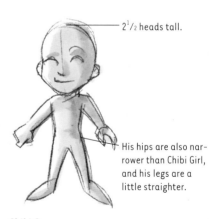

2$\frac{1}{2}$ heads tall.

His hips are also narrower than Chibi Girl, and his legs are a little straighter.

Shojo Guy

Shojo Guy is the basis for the Beautiful Boy and Bad Boy in shojo comics. He's also seen as the Father, Uncle and Big Brother, most often in shojo but sometimes also in shonen and drama comics. He is lean and leggy.

Chibi Girl

She is proportioned somewhat like the Baby, which is the secret of her appeal, but she's usually a cartoon version of an older character. Bring her in for sarcastic remarks, punch lines, or comic reactions. Keep her body very simple, otherwise she'll look weird, like a shrunken adult.

Chibi Guy

His body is the base for comic relief versions of characters, mascots, and shrunken comedy grandpas.

Nice Girl

The Nice Girl is a constant in manga. She's the Girlfriend, the Princess, or the Angel. In a team, she is always the leader. She inspires others with a cheerful outlook, perseverance and talent. Everyone loves her except her nemesis, who might be an equally talented Demon Girl or anyone else who decides to hold a grudge against her.

Nice Girl, Nice Hair

Nice Girls can also have braids, longer hair, one or two ponytails, or very short hair. Over a longer story, a nice girl with long hair will cut it to show she's growing up.

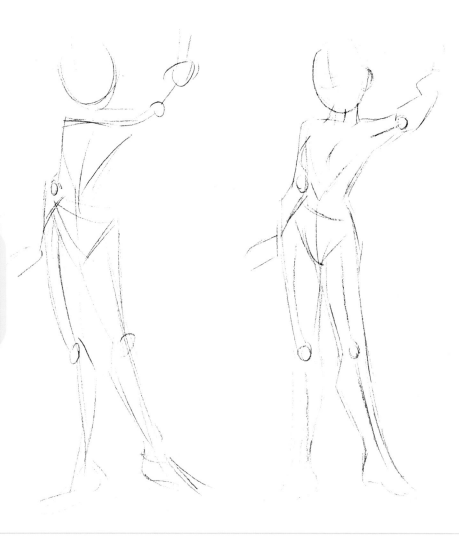

1 Create a Rough Sketch
Start by building the Nice Girl's skeleton, which is usually 6½ heads tall. Think of how she will stand. She isn't demure, like the Big Sister or Very Nice Girl, nor is she ready to scrap like the Tomboy; she stands in a confident, open way.

2 Refine Her Body
Flesh out Nice Girl's skeleton. Give her a cute, curvy build, but not extreme in her bust or hips. Remember, her body has to hold internal organs, so watch her waist size. Check to see that her arms are the right length relative to her torso and legs. Sketch in construction lines for her face.

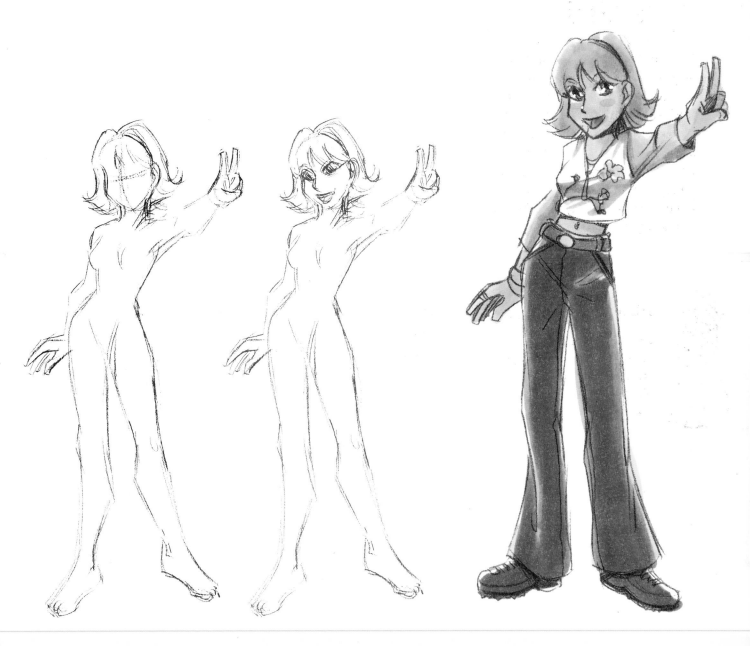

3 Begin Adding Features

Refine the Nice Girl's hair, ears, hands, and feet. Her hair will often be shoulder-length with bangs. She might have an unusual hair color, but rarely an edgy hairstyle. Her hands are open and relaxed, except for when she gives a thumbs-up or a "V" for victory! Hold her up to a mirror to see her in reverse, which will help you quickly spot any features that are placed incorrectly; make sure her ears aren't too low or too high.

4 Shape the Eyes and Mouth

Give the Nice Girl round eyes, but not too big. She doesn't wear lipstick so make her mouth "plain." Line up the corners of it with the middle of her eyes. Give her a smile. Her expression, if she's not smiling, will be thoughtful or pleasantly neutral—the Nice Girl tries not to cry or lose her temper.

5 Dress Her Up

The Nice Girl's clothes are always neat and quite cute, not too mod or sexy. Look at catalogs of teen clothing, or TV shows and movies with teen casts. Dress this Nice Girl in jeans and a blouse with a wrap-style bodice and loose sleeves.

Very Nice Girl

When the Nice Girl is taken to the extreme in young men's (shonen) manga, she becomes the Very Nice Girl. She is an immensely powerful person, robot, or deity, who is also naive and childlike. She always ends up with the hero—a guy inexplicably attractive to every girl in the universe despite not having a personality or a backbone. Even though she shares a body type with the Nice Girl, her hair, facial and body expressions are very different.

Don't Overdo It

Many Very Nice Girls are dressed as maids, or with head gear that suggests a cat (neko). Maids and Neko Girls are cute, but they've appeared so much in manga and anime, including as lead characters, they're a visual joke. You can come up with a new idea with very little effort.

1 Create a Rough Sketch
The Very Nice Girl wafts through a story, often literally. She is graceful and relaxed. She often holds her hands and arms like a ballerina's or clasped, either in her lap or as if she's praying. Draw this Very Nice Girl like she is floating, looking up with her hands clasped.

2 Flesh Her Out
The Very Nice Girl is sometimes voluptuous (usually in the chest), and can be a bit slimmer than the Nice Girl, depending on how racy the story is. Take the middle ground with this character. Remember to keep her lines smooth.

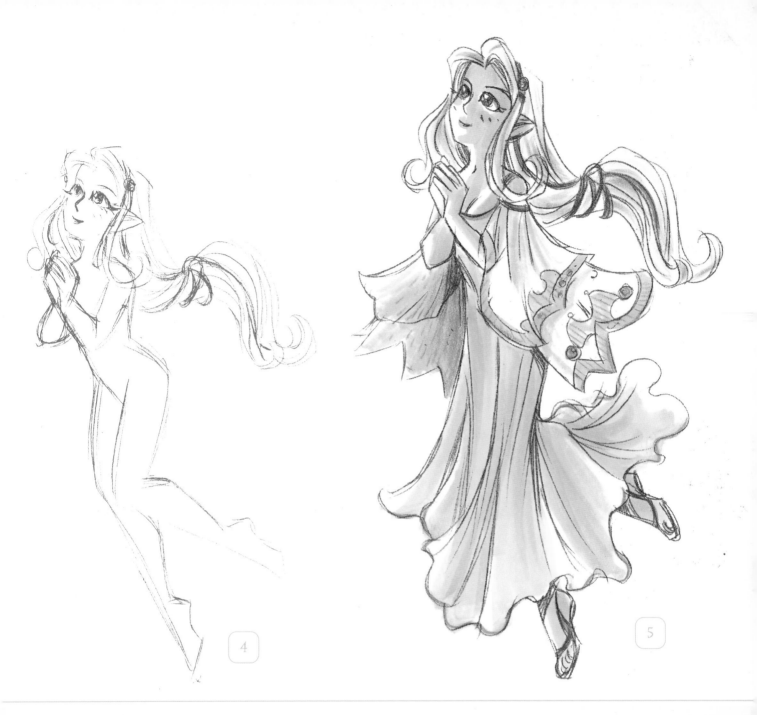

3 Refine Her Body and Add Hair

Give her long flowing hair, to emphasize her ethereal or regal nature. It seems to be moving in its own breeze, too! Make her ears on the small side. Draw her hands a bit longer than usual and have her hold them gracefully.

4 Give Her a Face

Very Nice Girl eyes are about the same size as Nice Girl's, but her mouth is usually smaller to emphasize her lady-like qualities. Draw the mouth so the corners line up with the inside corners of her eyes. Draw pupils in her eyes even though Very Nice Girls are often shown with no pupils, giving them an alien or vacant expression.

5 Design Her Dress

The Very Nice Girl favors flowing clothes with lots of detail: dresses, skirts, coats, or robes. Look at fashion, wedding, or prom magazines and jewelry catalogs for ideas. Also study Art Nouveau and Art Deco designs for inspiration. I picked an Art Nouveau nature motif crossed with an A-line coat and a prom dress. Be sure to study how fabric drapes and flows. Keep it simple: once you start putting folds and drapes where they'd never go, the Very Nice Girl looks rumpled, not rendered.

Airhead

The Airhead shows up in team comics or in an ensemble cast. She's pretty, with a sexy build. The Airhead isn't stupid, but she's unaware of other people's concerns. She can be very vain but most often she's not. She's always the comic relief, with her worries about boys and makeup. The Airhead's appearance can be summed up in three words: cute, cute, cute.

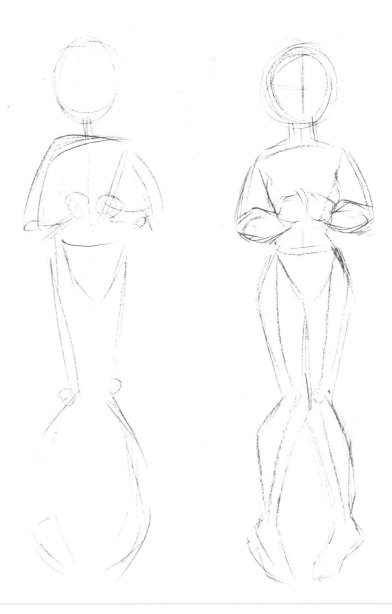

1 **Create a Rough Sketch**
The Airhead tends to stand and move the way she acts: childishly. Turn in her toes, put her thighs and knees together and her feet apart. She holds her arms behind her back, locked at her sides, or up at shoulder height. You can try all these different possibilities, but for now draw her arms bent and position her hands at her waistline.

2 **Add Her Curves**
Remember, she is on the voluptuous side, so make sure her shape is curvaceous and her bust is generous—but not ridiculous. Make her toes pointed, and curl in her fingers.

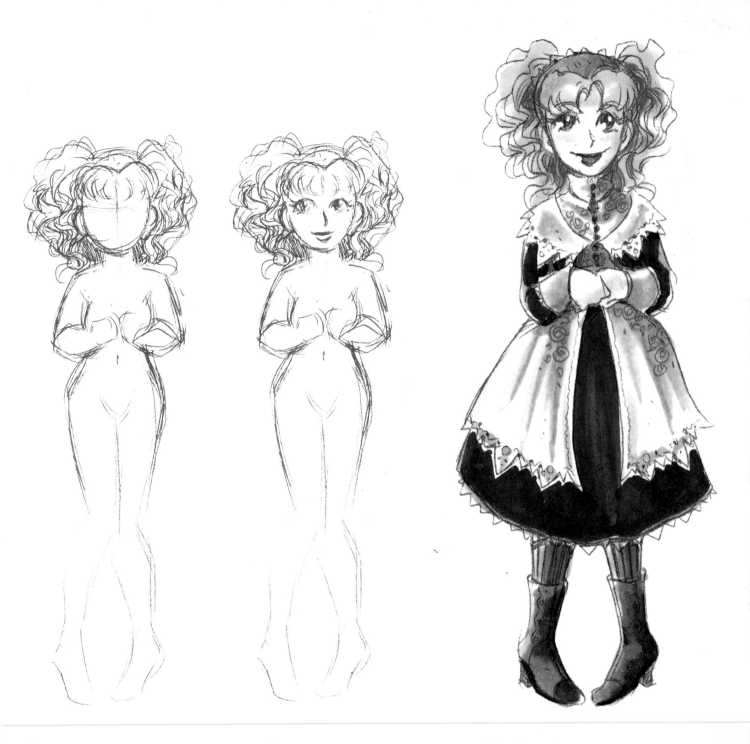

3 Draw Her Hair and Ears

Sketch the construction lines for her face, then add her ears and hair. Airheads favor fluffy, curly hairstyles. Her hair color is often pink or purple. Treat her curls as shapes, and leave room under that 'do for a skull.

4 Create Her Face

Give her a typical Airhead face with round eyes fringed with lashes and high eyebrows. Make her mouth full, and wider than the Very Nice Girl's. Draw a small and pointy nose.

5 Play Dress Up

The Airhead dresses sexier than the Very Nice Girl, but be careful, because the line between sexy and risqué is a fine one. Airheads like to be stylish above all, so this Airhead has chosen to dress Gothic Lolita style, with an outfit straight from a Gothic Lolita shop. She has a black silk dress with a lace bodice, petticoats, stockings, and old-fashioned shoes. She's pulled her curly hair into two ponytails and topped them with a lacy cap.

Bad Girl

The Bad Girl, despite her name, isn't always bad or the enemy of the Good Girl. She is sometimes the opposite of the Good Girl, the Outsider, or the Rebel. Her job is to speak her mind and say the things other characters can't or won't. She usually thinks she is the best, which is often true, and she isn't modest about it. If things come easily to her, she takes them for granted. She is usually redeemed as often as she is defeated.

Bad Girl or Good Girl?

In manga and anime, you know a Bad Girl will be redeemed if she has a more restrained hairstyle.

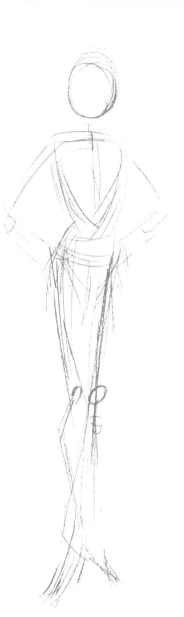

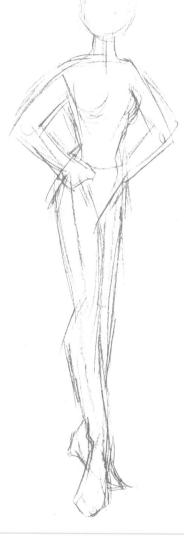

1 Build a Better Bad Girl
The Bad Girl is lean and mean, about 7–7 ½ heads tall. Her build suggests that even if she's not older than other characters, she looks older. The Bad Girl may be rude, but she's also dignified.

2 Fill in Her Body
Although the Bad Girl is lean, she is usually on the busty side because she's the visual opposite of the Good Girl. Give her a sizeable bust, but make the rest of her athletic.

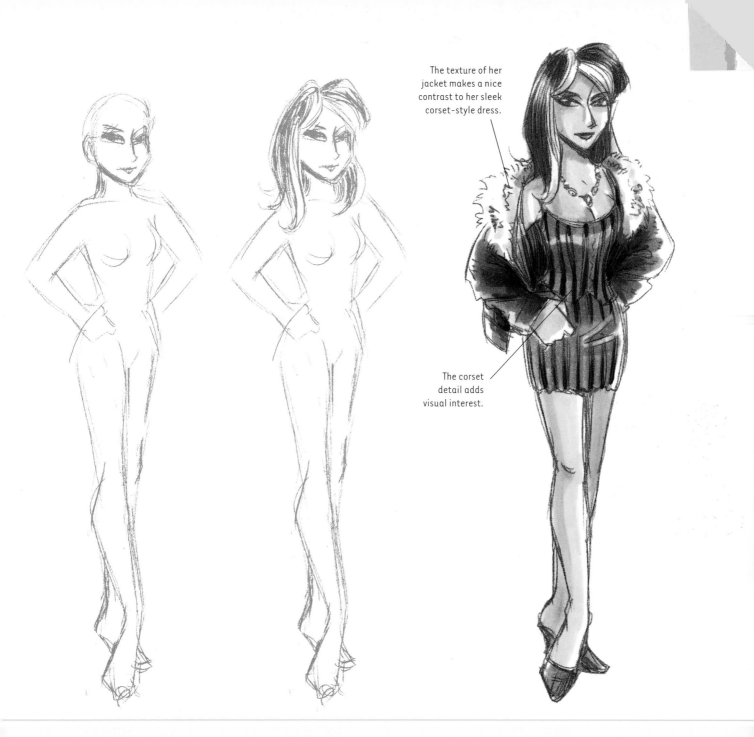

The texture of her jacket makes a nice contrast to her sleek corset-style dress.

The corset detail adds visual interest.

3 Draw Her Face

You know the Bad Girl is most definitely bad by her face. She has much narrower (but still pretty) eyes, and thin eyebrows. She has more defined lips than the Good Girl, and is often drawn wearing lipstick. Her mouth is small, like Very Nice Girl's, and placed the same way. Her nose may be large and regal, or it may be small and pointy, but it, and everything about the Bad Girl, is angular. Draw this Bad Girl with big eyes, a pointy nose and a small pursed mouth.

4 Add the Hair

The Bad Girl has the coolest hair. She's the girl who wears a mod style in outrageous colors, especially if she's a rebel. Sometimes her hair is simply long. Let's give our Bad Girl a shoulder-length mod hairstyle with bangs.

5 Style Her Clothes

The Bad Girl is always stylish, whether it's an outsider look like Goth, a severe business suit, outrageous street-inspired style, or sleek and sexy. Since she's a rebel, give her a little, sexy, fitted dress with a leather jacket.

Tomboy/Nerd

The Tomboy and the Nerd go together because they share a boyish body type, short hairstyles, and a preference for things usually thought of as being for guys: sports, mechanics, math and science. The Tomboy is active and always ready to prove herself, and her body language shows it. The Nerd is shy and she stands demurely, like the Very Nice Girl, but without self-assurance. Let's draw them together as sisters.

Defying Stereotypes

Usually, the Nerd would be the short character and the Tomboy the tall one, but I decided to play against expectations here and make the Nerd tall and self-assured and the Tomboy small and shy. You can do this yourself—make an Airhead type very smart, make a Beautiful Boy type dumb, or let a Brute or Demon be the hero.

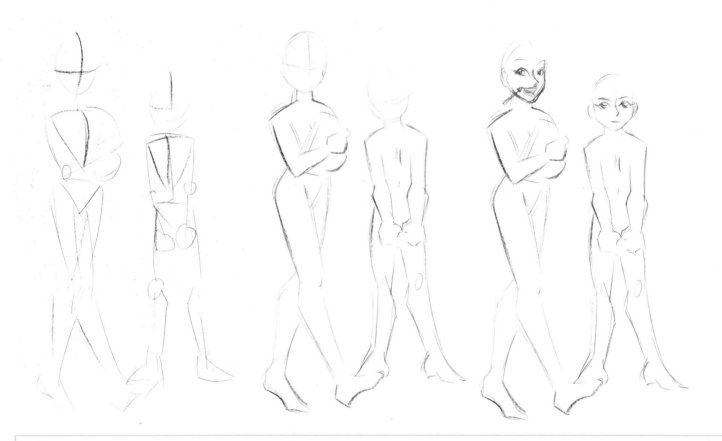

1 Create a Rough Sketch

The Nerd is about 6½ heads tall; the Tomboy is 5½ heads tall. The Nerd's pose suggests she's on her way somewhere with something in her arms, while the Tomboy's feet are apart, and her arms are in front of her.

2 Refine Their Bodies

Flesh out the girls. Keep in mind they have lean bodies with small busts and hips.

3 Add Their Faces

The Nerd has smaller eyes than the Nice Girl, but larger than the Bad Girl. Draw her mouth between the midpoints of her eyes. Draw round eyes and a small mouth on the Tomboy. Go easy on lips and eyelashes on both of them to keep their boyish looks.

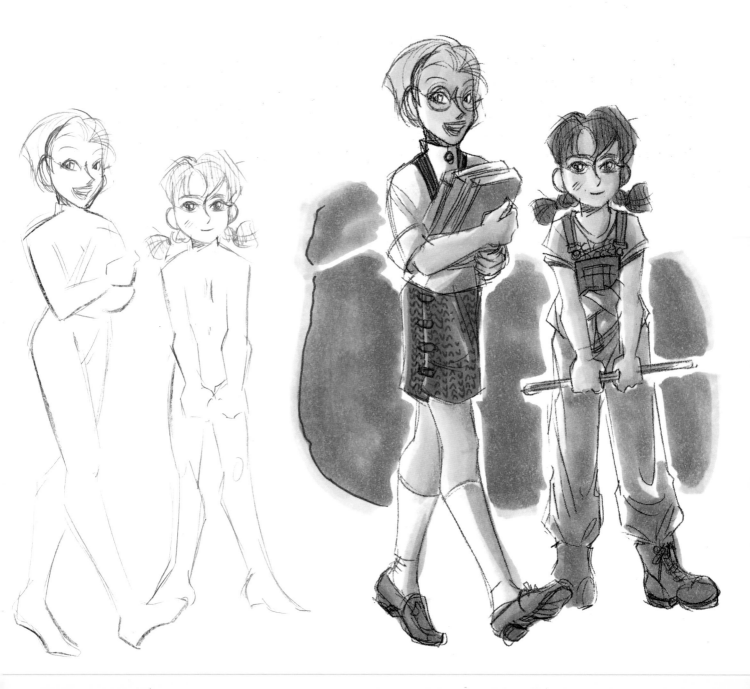

4 Style Their Hair

Add their hair, giving the Nerd a neat and straight bob held back with barrettes, and the Tomboy two short braids with shaggy bangs.

5 Design Their Clothes and Accessories

Let's say this Nerd goes to a school with a uniform code and wants to be a manga-ka. So she'll be dressed in knee socks, sensible tartan, loafers and a shirt and tie. She also wears the obvious visual cue of nerdiness: thick glasses. This Nerd carries a stack of books, but they're all manga weeklies!

Tomboy likes to fix her own car. Today the job was replacing a fan belt, so she is holding the tool for that. She is dressed in boots and a coverall. She's wearing a T-shirt from a car show. Let her coverall be baggy all over, especially around her ankles and legs.

Little Girl/Baby

The Little Girl and her younger sibling, the Baby, are mascots to older characters, sometimes appearing as the kid version of a super-powered character or simply as younger siblings or children of older characters. They can also trick other characters, or provide comic relief. Keep their lines simple and soft, and make sure their facial proportions are correct so they look like kids, not dwarfs. This Little Girl and Baby are drawn as companions to demonstrate the differences and similarities between them.

Observe Kids

Watching kids helps with drawing them. Kids are not only natural-born comedians, they're a fresh window on the world, since almost everything is new to them.

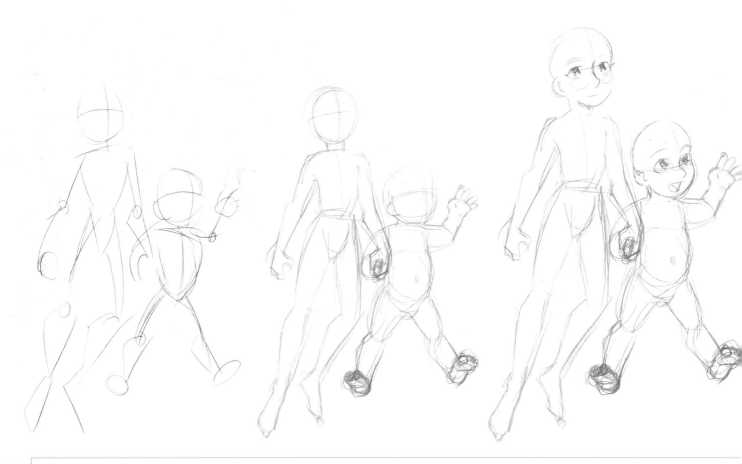

1 Make a Rough Sketch
The Little Girl is about 4½ heads tall, while the Baby is 3½ heads tall, but they both have the same head size.

2 Fill Out the Bodies
Draw the Little Girl as a skinny pre-teen. Make her sibling very roly-poly by drawing a roll of body fat at every place she bends. Baby arms are shorter, proportionally, than anyone older. Their fingertips end just below the crotch instead of mid-thigh.

3 Make Baby Faces
You can cheat by giving the Baby very big eyes. Baby eyes are large, but here I've made them extra-big to emphasize her youth. Even though Little Girl and Baby have the same-sized heads, their features are placed differently. Place the Little Girl's features halfway down her face, and the Baby's slightly lower. I made the Little Girl's eyes on the small side, as a contrast to the Baby's.

48

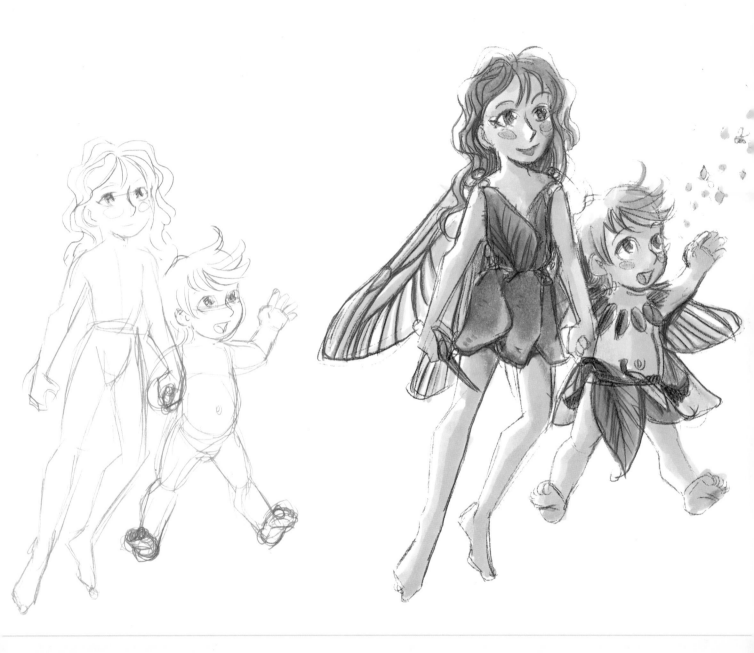

4 Draw the Hair

Because I'm designing the Little Girl and Baby as a pair of woodland spirits, I wanted their hair to look a bit unkempt. Draw the Baby's hair flying away and her sister's as cascading waves.

5 Style their Costumes and Accessories

Your characters' clothes give the reader an idea of where they live, how much money they have, and their social status. Since these girls are tiny woodland fairies, design their clothes with rose leaves and flower petals. The Little Girl's dagger is a mesquite thorn. Their wings are based on dragonfly wings. Nature is an endless source of inspiration.

Big Sister/Mama

The difference between the Big Sister and the Mama is a mere few years of age. In manga, the Big Sister (Onesama) serves as a role model for the Nice Girl. She also might be a surrogate mother in a story where the mother is gone. Big Sister and Mama are composed and gentle, but are no-nonsense when it comes to getting people in line; they might even show their fiery temper! They represent a traditional idea of a woman: she works hard, steers everyone else, and keeps things running smoothly.

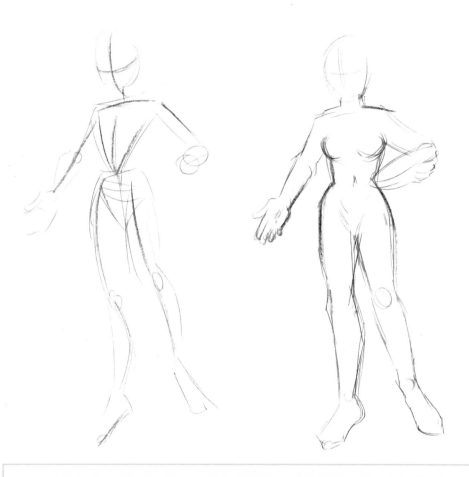

1 Create a Rough Sketch
Let's make her a fantasy temple priestess with an outfit based on traditional costume. Make her 7 heads tall. Give her a smaller head relative to the rest of her body, suggesting she's an adult. Rough in her body as if she's walking slowly with most of her weight on her forward foot. Draw one arm up to hold a large bowl, and one hand out for scattering food or flowers. To get a feel for this pose, model it in front of a mirror.

2 Refine Her Body
She's got a slim but more mature body than a teenager. Her hips are wider and her bust is lower and larger. Study your hand turned out to draw her hand correctly. Also study your feet and see how the weight-bearing foot points out slightly, while the other foot points to the side and back. Make sure her arms don't look too long or too short; it's easy to end up doing either when you're not drawing them hanging at her side. Draw her bowl, keeping in mind that a bowl is a curved shape and perfectly round only when you see it from straight above or below.

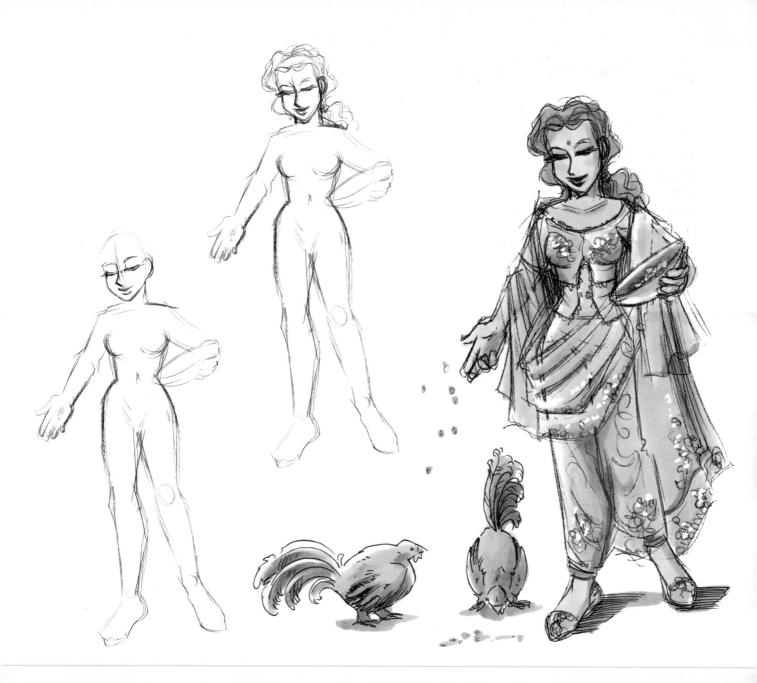

3 Add Her Face

These characters have beautiful eyes, but not as round as a younger person's. Her nose is a matter of preference, but let's give her a distinguished one. Draw her mouth slightly less wide than the width between her pupils; make full lips.

4 Draw Her Hair

Big Sisters/Mamas almost always keep their hair long, either braided or softly pulled back and laid over one shoulder. Let's give Big Sister/Mama a soft pulled-back hairstyle.

5 Design the Costume and Props

I based this costume on the traditional Indian outfit of blouse (choli), baggy pants (salwar) and shawl (dupatta). I did an Internet search to find reference pictures. Keep the pants loose and flowing, but remember the legs under them. The top is form-fitting, and the dupatta drapes around her torso, making a nice line behind her and swinging with her steps. Add a decorative pattern to her pants and choli. I picked a paisley motif but it could easily be stripes, flowers, or anything else. Give her some bracelets, earrings, and a forehead jewel (bindi). Refine the bowl and decide what she's scattering. I decided that she is feeding some crazy-looking chickens, but yours could be tossing petals, seeds, bread, or candy.

Obaa-san and Oldsters

In manga and anime, older women and grandmas (Obaa-san) come in two flavors. Less common is the dignified older woman who looks just like Big Sister/Mama, only with lines in her face, round shoulders, and a soft jaw from her skin losing elasticity. More common is the comedic dwarfish old grandma who is as short as 2½ to 4 heads tall. She has a head like a dried apple, with an outrageous personality that comes from being old enough to always want her way and not care what anyone else thinks. Her dwarfish stature is based on her spine compressing with age, causing her to lose height and stoop. You'll draw this second "oldster" here.

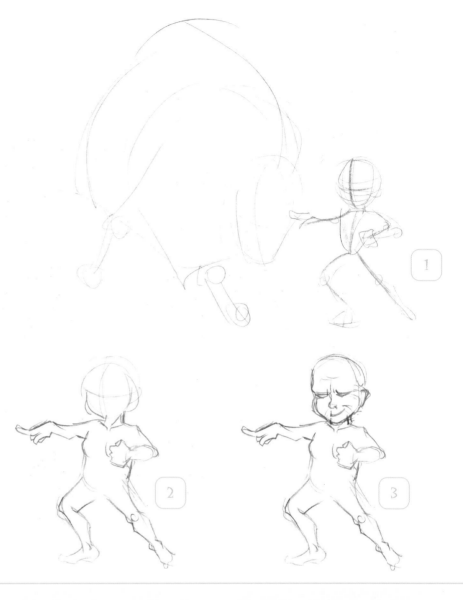

1 Establish Gramma's Height
The sillier your story, the fewer heads tall your Gramma is. Draw this Gramma about 3 heads tall. My own Gramma was a dairy farmer and once chased me out of a bull's pasture; then she chased the bull. This granny is going to be stopping the bull in its tracks with a karate chop to the noggin. Sketch her figure at that very moment of hand meeting head, making sure the bull is outrageously large.

2 Add Some Details
Gramma is believable because her body is like a real grandmother's even though she's a cartoon. Draw her thick around the middle, making her chest considerably less rounded, her arms and legs thin, and her hands delicate with prominent knuckles. Anywhere Gramma has a joint, make it stick out, since her skin is thin and dry.

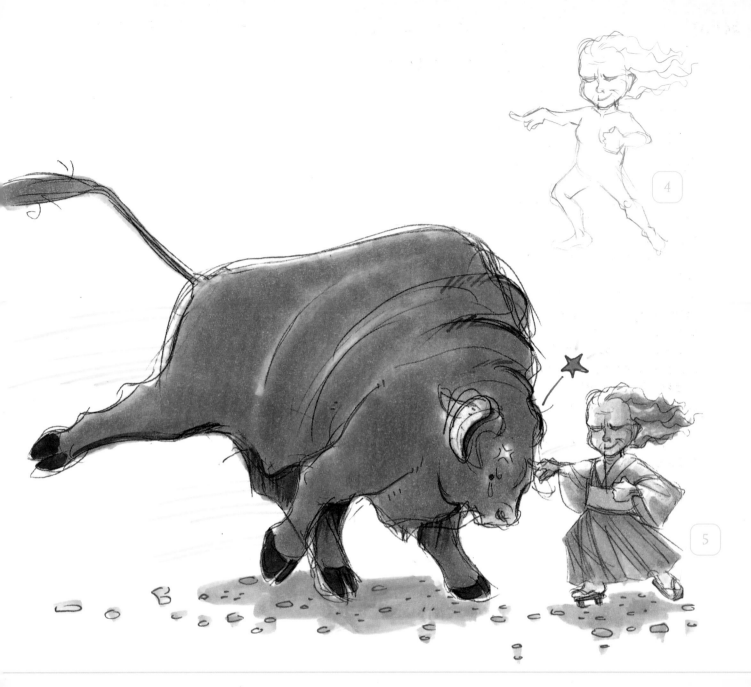

3 Form the Apple Head

Draw many interesting wrinkles on her face. Remember, they didn't happen randomly; they're a combination of lines from habitual expressions and her skin beginning to drape on her skull. The cartilage in her nose is receding, so make her nostrils more prominent. Her mouth is soft. Decide how many teeth she has left. These days, a toothless oldster would be someone who was poor or who lives someplace remote. Here, she's being comically severe, so set her mouth in a line, and draw closed eyes in an "I-don't-need-your-guff" expression.

4 Draw Her Hair

Pretend Gramma has taken good care of her hair, so it's not thin or gone. Draw her with a head full. However, it has gone gray, and hair with little or no color has a wiry and coarse texture. Draw the hair with waves bent into it from a braid or bun. Remember to show it as shapes, not lines.

5 Design Her Clothes

Let's give Gramma a traditional kimono, socks (tabi) and sandals. You can find reference pictures of these on the Internet. Make sure you draw the folds where her sleeve bends at her elbow, and use the lines of her kimono to emphasize her action.

Big Gal

The Big Gal is pretty maligned in anime and manga. In a world of sylphs, she sometimes gets a plump part, like a mother or pirate queen in Hayao Miyazaki films. More often, she's big, dumb, homely, gluttonous and the butt of jokes—when she appears at all. But out of respect for all the Big Gals who are athletic, smart, charismatic and good-looking, it's time to design one for manga who's the same!

Screen Note

Hayao Miyazaki is the director of films like *Kiki's Delivery Service*, *Laputa* (*Castle in the Sky*) and and the Oscar-winning *Spirited Away*.

1 Create a Rough Sketch

Your Big Gal can be anywhere from 5–7 heads tall. She is about 6 heads tall. Remember, at 5 heads, she will look younger; and at 7, more Amazonian. Give her a normal skeleton; it's her body fat and muscle that make her shape. Let's make her a sensual Roaring Twenties singer. Indicate her shoulder, putting it a bit high to give her attitude. Have her taking a step to the side, throwing her hip out, and sliding her other foot along. Her torso is turned away from us, so she's in three-quarters perspective. Tip her head slightly back.

2 Refine the Big Gal

Add the Big Gal's flesh, keeping her round all over, but with slender ankles and wrists to contrast her curves. Since her bust is mostly fat, give this Big Gal a generous one. Watch the placement of her feet: the one she's stepping on points out, the other to the side so that we can see the top of it. Draw her hips first and then her arms, placing her right hand and arm on her right hip and the other arm down at her side. Create rounder and wide shoulders than what you would find on an average-sized woman.

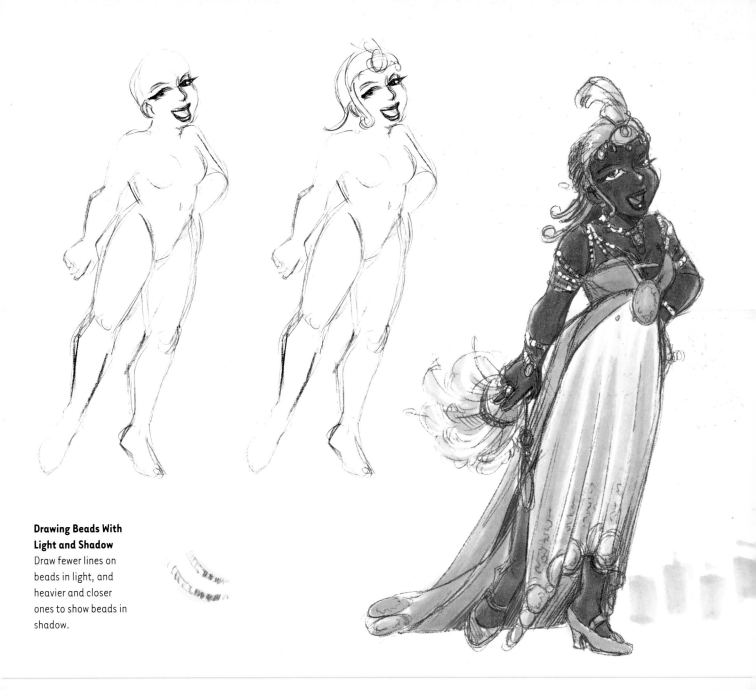

Drawing Beads With Light and Shadow
Draw fewer lines on beads in light, and heavier and closer ones to show beads in shadow.

3 Add the Face
The Big Gal, like any large person, carries her weight everywhere, including her face. Draw a soft jaw and a round face. Her eyes and mouth can be any shape or size. Make her eyes medium-sized and catlike. Draw her an open mouth so she can belt out her songs. Give her a sultry expression.

4 Draw Her Hair
Since Big Gal is a Roaring Twenties singer, she needs a period hairstyle. Short hair set in waves and very short bobs were both in vogue, as was headgear (a hat) that covered all the hair. This is a good time to use your library or the Internet to find authentic hairstyles. Sketch the lines of the hat along with her hair.

5 Design Her Outfit
Consult your reference for Big Gal's dress. Some of the best-known fashions of that time were designed by Erté, known for his decorative details and luxurious materials. Let's go for a floor-length dress with Erté-inspired Art Deco motifs and beaded fringe on the dress and headdress. You don't have to draw every little bead; simply putting in two lines with even spaced lines across suggests beads very well.

Nice Guy

The Nice Guy is somewhat akin to the Very Nice Girl, that is as a character he puts up with a lot. He's also the counterpart of the Nice Girl: he's a leader, a hard worker, good to other people, honorable and never gives up. This is reflected in his appearance: not too tall, not too short, not too weird-looking. His personality is also apparent in his dress, which is almost always correct for the occasion. From the basic Nice Guy, you learn about drawing male features that apply to the Beautiful Boy, Bad Boy, Nerd, Big Guy, and Adult Male. Like the other characters, these are general observations. After learning them, try making your Nice Guy very tall or not human, and see where that leads you!

1 Rough in the Guy

The Nice Guy will be a tiny bit taller than the Nice Girl, so he needs to be about 6½ heads tall. Form his body in a pose that suggests a dude very comfortable with himself. His posture is relaxed with one hand in his pocket, the other down at his side.

2 Refine Him

Add shape to the Nice Guy, making his torso triangle-shaped and his shoulders wider than his hips. Since Nice Guy is an average guy, he's neither very skinny nor muscled, so don't go crazy with the chest and shoulders. Shape his right hand as though it is holding something because he is going to be carrying a messenger bag. His weight is equally distributed on his feet so they're both flat.

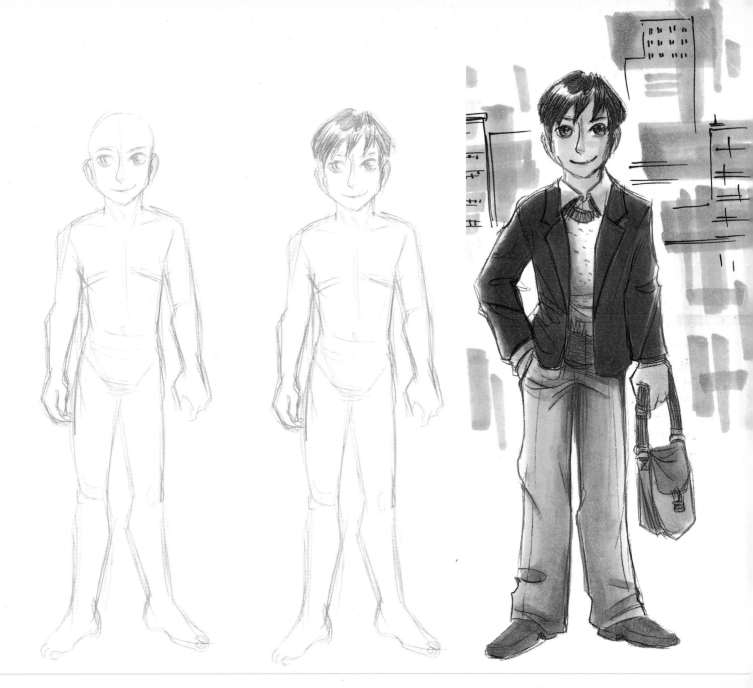

3 Make a Nice Face

Unless he's upset or crazy happy, the Nice Guy usually looks pleasant, even bemused. Draw his eyes smaller than a girl character's. Indicate his eyelashes by a heavy line on his upper eyelid—not with individual eyelashes. Define his lips by either drawing the horizontal line where the lips meet, the inside edge of them, or his lower lip line. Draw a square jaw, and make his Adam's apple visible in his neck.

4 Draw His Hair

Make the Nice Guy's hair stylish, but not too unusual. It should be short on the sides and back, a bit unkempt, but not too shaggy. Give him dark hair and watch the highlights.

5 Final Details

Draw a jacket over his clothes because this Nice Guy goes straight from college to work. Draw his messenger bag. Have all but the top two buttons of his shirt done—the open collar look is the province of the Bad Boy. Check men's magazines for fashion that's classy and interesting, but not too edgy.

Beautiful Boy

The Beautiful Boy is the equivalent of the Bad Girl: long, lean, gorgeous, seductive and impossibly attractive. He's a staple of shojo comics, where he is the Smooth Criminal, the Bad Boyfriend and the Bad Guy everyone loves to hate. Unlike the Bad Girl, he's usually evil to the bitter end. He is less likely than the Bad Boy to be redeemed or do something noble. He is always dressed beautifully and stylishly. His hair is long, but it is always sleek and smooth, symbolizing his inner self: outside of social norms, yet precise within himself. He's never dirty because he has minions to carry out his dirty work—until he's forced to take matters into his own hands, at which point he loses. This Beautiful Boy is going native, with a Balinese-style costume to show off his chest and arms.

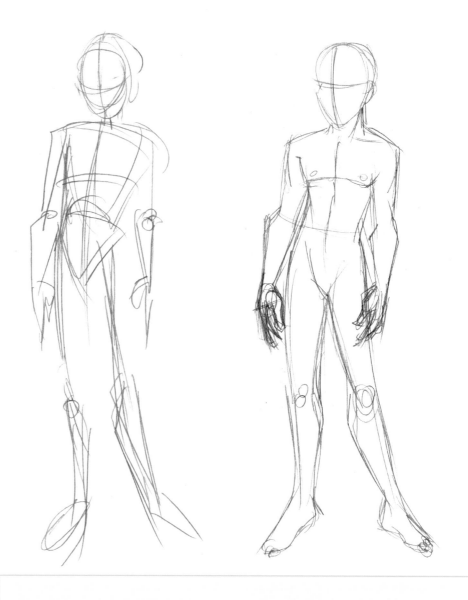

1 Create a Beautiful Rough
Make him 6½–7 heads tall. The Beautiful Boy is always relaxed, like the Bad Boy, but he never slouches. Draw his hips forward and his arms in a relaxed position.

2 Flesh Him Out
The Beautiful Boy is elegant. He falls physically between the Bad Boy and the Goth Boy. Give him a very lean build, but don't make him look like he's underfed. Draw his feet, paying attention to where they point.

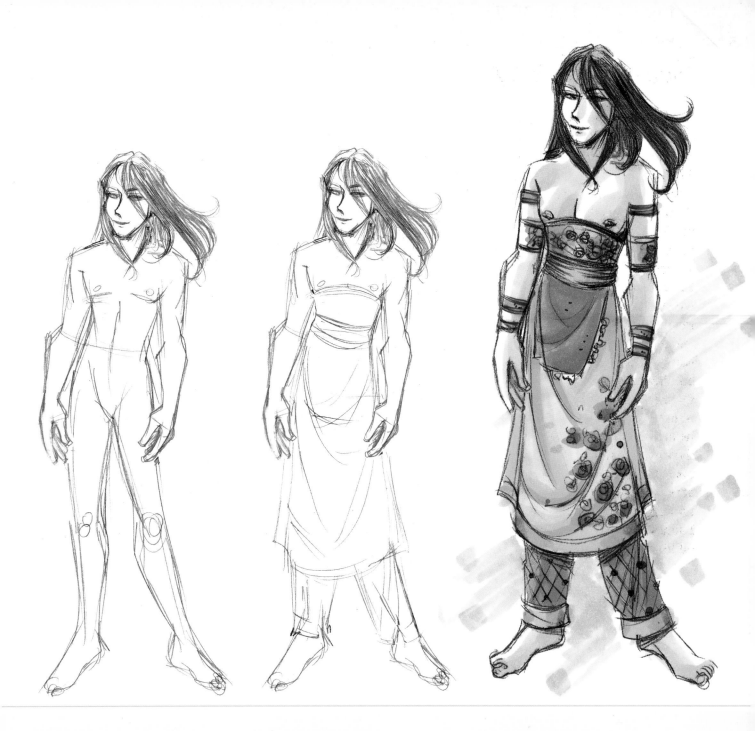

3 Draw His Face and Hair

Give the Beautiful Boy angular features like the Bad Girl: catlike eyes that are long but not large, a mouth that's sensual but not full. Beautiful Boy habitually keeps his eyelids a bit low—he's always sizing someone up. Give him cheekbones, but don't draw too many face lines (too many age a character). Show off his hair. This style suggests a breeze that affects only hair and not the clothes!

4 Style His Clothes

Sketch a wide-belted sarong over loose pants. The belt is snug; have its lines follow the curves of his torso. Make them curved, not straight. The sarong is flowing; give it long, soft, curving wrinkles across the front. Pants are much easier to draw after looking at someone wearing them. Most artists draw too many wrinkles, placing them wherever. Even though you can't see Beautiful Boy's knees, the wrinkles in his pants originate at his knees. Draw only a crease or two in them.

5 Accessorizing Your Boy

No matter what he wears—suit, tux, sarong, uniform, casual or formal, he will always accessorize perfectly— and expensively. Here, he has a neck-lace, bracelets, and arm bands. Pay attention to how these hang—they curve around whatever they hang on. Draw a luxurious pattern on his sarong and pants.

Bad Boy

The Bad Boy isn't bad, he's just a rebel. The classic Bad Boy drifts through life searching for redemption. He's crude but kind; an angry fighter but would never hurt anyone or anything for the fun of it. The Beautiful Boy is far more likely to be cruel and immoral. Two things you should always give a Bad Boy are an open collar (no matter what his costume or era) and messy or unusual hair. Both of these visuals come from manga, where the Bad Boy didn't button his uniform collar, and didn't have a short, neatly combed haircut. Our Bad Boy is with the Shinsengumi, the 1860s swordsmen working as police in Kyoto, Japan.

Costume Resources

I found Bad Boy's outfit online at www.shop-japan.co.jp/english-boku/shinsengumi.htm. This isn't strictly accurate Shinsengumi, but more along the lines of a costume. A good page to learn everything about geta is www.karankoron.com. "Karan-koron" is the sound someone makes walking in geta.

1 Create a Rough Sketch
The Bad Boy is always either tall for his age or an adult, so draw him about 7 heads tall. He and most of his brothers walk with a habitual relaxed slouch. I started him with his hands in his pockets (a typical Bad Boy thing to do) and angled his head down.

2 Flesh Him Out
Indicate the line for the Bad Boy's wooden practice sword (bokken) with a line through him so the sides match up. His arms dangle below the bokken. Draw him fairly lean, but not too skinny. He's stepping forward with his left foot, and lifting his right, so his right knee is bent, and his right heel is behind his left. Since he's turned slightly, his body hides part of his right arm.

3 Draw His Hair and Face
A Bad Boy's hairstyle is usually big. This Bad Boy has a manga-correct mop, and is wearing his headband (tenugui). Draw the headband so it follows the shape of his head—curved because the head is a round shape. Give him a mature face shape by making a square jaw and small eyes. Draw the corners of the mouth in line with the centers of his eyes.

Drawing Geta

The geta is a rectangle of wood with a strap (hanao). Note that on the bottom there are two teeth (ha), in the middle and near the back. The hanao is tied in front of the back ha.

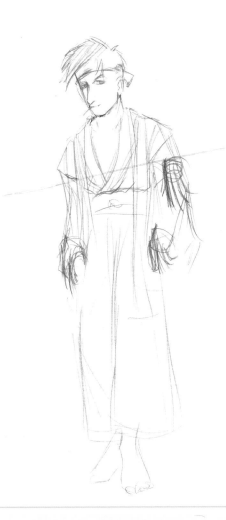

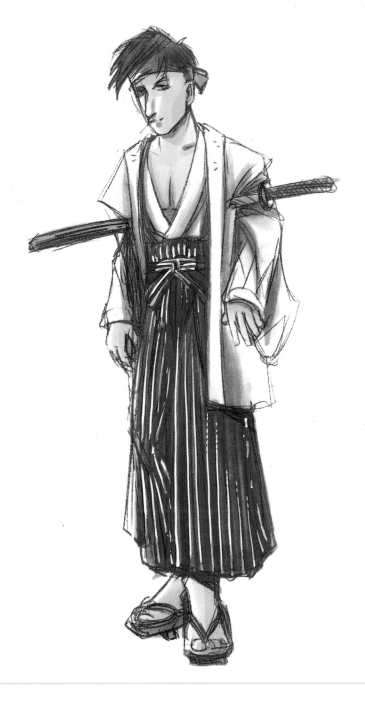

4 Hands and Costume Shapes

This costume is pretty complicated, so place his hands and sketch the outlines for his Shinsengumi uniform. Since he's a typical "open-collar boy," his kimono is not pulled tight, but hangs open instead.

5 Finish Your Bad Boy

Finish his hands. His uniform coat (haori) has square sleeves and a square body that hangs to his knees. The shoulder seam is on the upper arm. The bottom of the sleeve hangs free, so it sticks out when the arm is bent. The bokken pressing into his arms also makes some extra wrinkles. Include the triangle detail on the sleeve edge. Since he's a Bad Boy, his kimono is carelessly fixed. Draw his striped pants (hakama) full, pleated, open at the sides, and held up by tying them. His right knee causes a bit of draping and wrinkling. Don't overdo the stripes, unless you're going for a very designed look. Last draw his shoes. A proper Shinsengumi would be wearing two-toed socks (tabi), but that's not Bad Boy's style.

Gemo the Goth Boy

This was going to be a stereotypical pocket protector, thick glasses nerd, but that's the nerd of yore. The new Nerd is Emo, complete with 1970s clothing, hair spiked in back, bangs in front, everything too tight, and NOTHING matches. Goth boys are pretty nerdy, too; everything they wear is black or goes with black, and they usually ponder introspective thoughts like, "Am I a boy or a girl?" Androgyny/femininity is a plus for male Goths. Clunky black shoes go for both styles. I combined those two styles to introduce Gemo, the Goth Boy.

Goth Boy Poses

Other good poses for Gemo would be sitting with knees tucked up under his chin, sitting with his feet sticking straight out, smoking, or the classic fetal position.

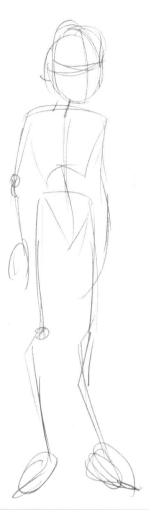

1 Create a Rough Sketch
Draw Gemo's basic body about 6½ heads tall. Begin with a gesture drawing to capture his general malaise: a slouch with the chest caved in, shoulders curled forward, stomach thrown out, head thrust forward on his neck.

2 Flesh Him Out
Gemo doesn't have much flesh to flesh out. Draw a skinny dude, even skinner than he is here. Make him standing in 3/4 perspective. Draw narrow shoulders, which are still wider than his hips.

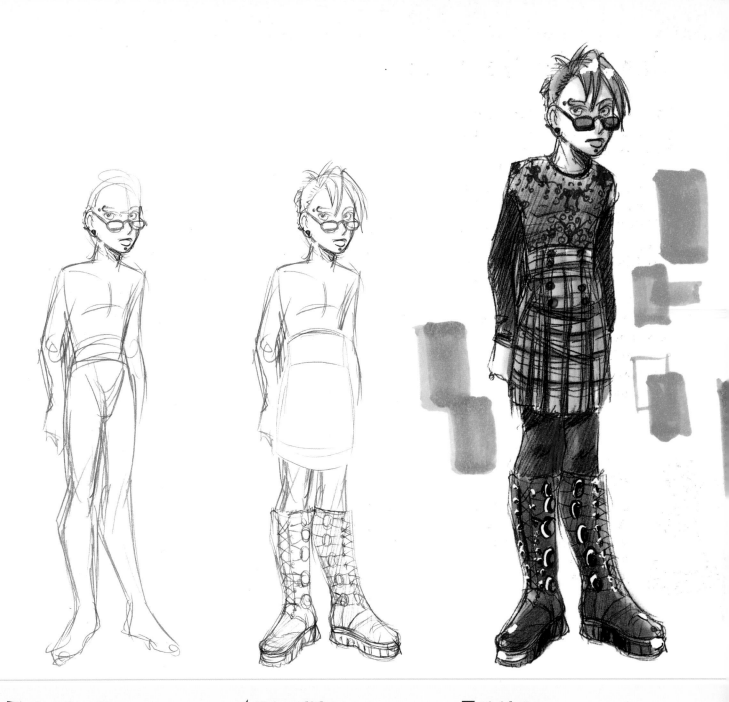

3 Give Him a Face

Gemo's been experimenting with all sorts of piercings: tribal (that big black rock in his earlobe), labret (lower lip), eyebrow, and in the cartilage of his ear. He probably has more, but he's wearing clothes. Give him soft, slightly feminine facial features: a full mouth and large round eyes. His glasses are classic Emo style: thick, but fairly small frames. (An Emo girl wears vintage rhinestone cat's-eye frames.)

4 Hair and Shoes

Gemo's hair is more punk than Emo, with very long spiked bangs and short spikes in back. You could vary that by drawing too-short bangs and a high cut over the ears, like Spock from *Star Trek*. Draw thick boots with heavy soles. Draw the laces in the right place by placing them along a line running up the front of the leg. His shoes have little to do with the actual foot shape beyond the direction the feet are pointing in and the foreshortening of the foot. Shoes that aren't so bulky come closer to showing the shape of the foot.

5 Finish Gemo

Give him tights, a button-up kilt made from recycled 1970s curtains (oh so Emo) and a mesh shirt with solid fabric panels on the arms, made from recycled 1970s and '80s printed T-shirts. For the perfect look, every color that is not black must clash. Gemo's the perfect combo—a bit overdressed for Emo, a bit underdressed for Goth.

Big Guy

Big Guy is usually poor at sports, the butt of jokes, or a clown. Sometimes he's lucky enough to be the steady, solid cast member, a guy who anchors the team. The Big Guy is not the Brute—an impossibly huge person or creature who can be either a good guy or a bad guy. I prefer the Big Guy to be a person. This Big Guy is a 1950s-style lounge singer. He's funny, yes, but also a little demented.

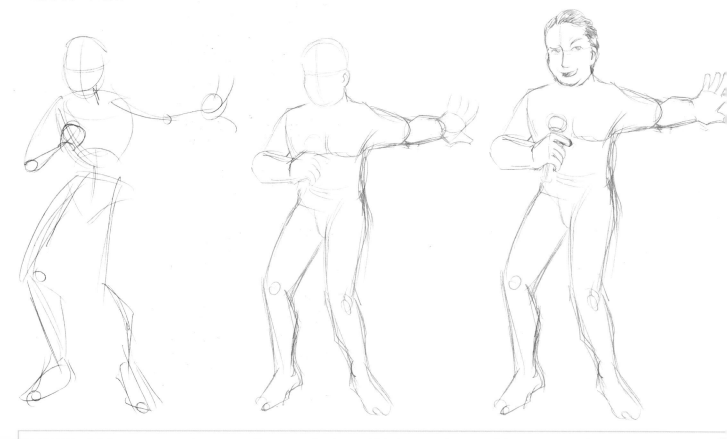

1 Create a Rough Sketch
Draw this Big Guy about 6 heads tall. He's working his lounge style so make the mike close to his mouth, with his free arm thrown back. His bone structure is not any larger than average. Remember, fat people don't have fat skeletons!

2 Give Him a Shape
Draw him carrying weight in his face, shoulders, arms, chest, middle, and a bit in his thighs. Sketch his fingers. Rough in his feet, using correct foreshortening on his left foot, but don't get too detailed because you'll eventually draw shoes over his feet.

3 Draw His Head, Hands and Hair
Give this Big Guy a round chin and jaw, round cheeks and a big head. He's into his performance, so give him an expression that shows it—a cheesy eyebrow raise and smirk. Keep his eyes small. His hair is short, neat and shiny with hair dressing; it's not quite an Elvis pompadour. Fat ends up everywhere on his body so his hands are slightly bigger than usual. Curve his fingers around the microphone, with the index finger loose. Spread and stretch the fingers on his free hand—that hand is talkin', baby!

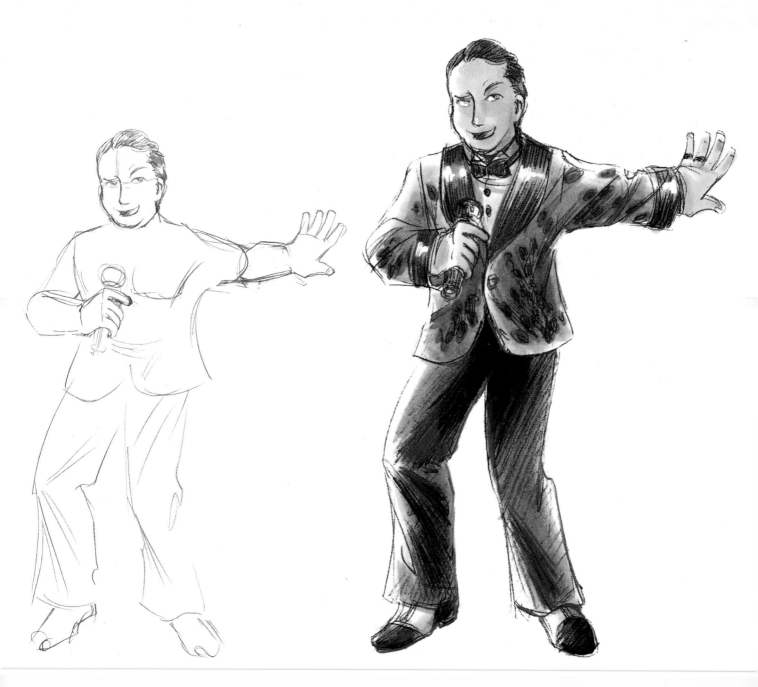

4 Design His Clothes

The folds in Big Guy's pants project from his knees; that's true anytime a joint bends inside of a sleeve or leg. Sketch a rough outline of his jacket, with the hem slightly higher on his left side because his arm is raised.

5 Accessorize—Lounge Style

Anything velvet, animal print, or both says "lounge." Give him a leopard-print jacket with velvet cuffs and collar. Keep the lapels wide enough to land a plane on. The fabric twists around his left arm because it's stretched and lifted. His right arm makes a crease from the body of his jacket into the sleeve. Draw his pants as a black shape with a few white lines defining the creases. His shoes are two-tone wingtips with a low heel. Draw the right shoe so it shows the top and inside; the left shows mostly the toe and some top. Because lounge is so classy, he wears a tuxedo shirt with black buttons, a bow tie, and rings on his fingers.

Papa/Big Brother/Little Boy

Papa is the Nice Guy grown up. His type is most often seen in shojo comics, where he's also the Dad, the Uncle, or a reformed Beautiful Boy. He's a sweetheart—steady and true, gentle and patient. Unlike the Nice Guy, he knows who he loves and who loves him. He is a dad of the 1910–1920s, with his son who's about six and a one-year-old baby. This demonstration will teach you the correct sizes of children relative to adults.

Sizing Mistakes

A common mistake in Western comics is to draw kids with adult facial proportions and small bodies, making them look like dwarves. In both Western comics and manga, children and babies are often drawn much smaller than they really are, to emphasize their smallness, so babies end up the size of capuchin monkeys, and children the size of babies!

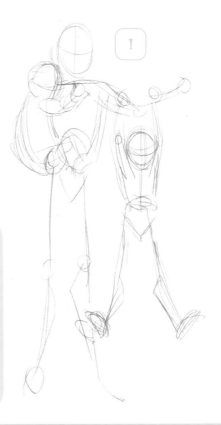

1 Sketch a Rough

Make your stick figure of the Papa holding the Baby in one hand, and letting his son dangle from the other. Since he comes from shojo, the Papa is leggy—most of his height is there—but he still has elbows at his waist, and fingertips which fall mid-thigh. The Baby sits on his forearm, resting on his hip; his arm wraps around the Baby's back.

2 Flesh Out Papa and Baby

Make Papa fairly slim, but muscular. Draw Baby's body as a bean-shape with round arms and legs. Baby's shoulder overlaps his head. He is hanging onto daddy's collar. Baby, standing up, would come to Papa's knee. Papa's hand is around Baby's leg. Hold a round object yourself and look at your hand to see how your fingers curl around it to help you get this right.

3 Flesh Out Brother, Add Faces

Draw the Little Brother as a slight fella. Since he's dangling, his body is stretched out, with his head between his arms. His fingertips just reach around his Papa's arm. If he were standing, his head would be level with Papa's pocket.

Add Papa's and Baby's faces. Keep Baby's features lower on his face. Draw round eyes, and a laughing mouth. Keep his ears small. Since Papa has a big smile, his eyes are almost closed; suggest them by drawing two "rainbow" shapes. His eyebrows curve above his eyes and his ears stick out. His hair is short and styled away from his forehead with a wave. Draw a line to describe the side of the nose. His glasses don't have the pieces that hook behind the ears; I left those off because they mess up the lines of the face.

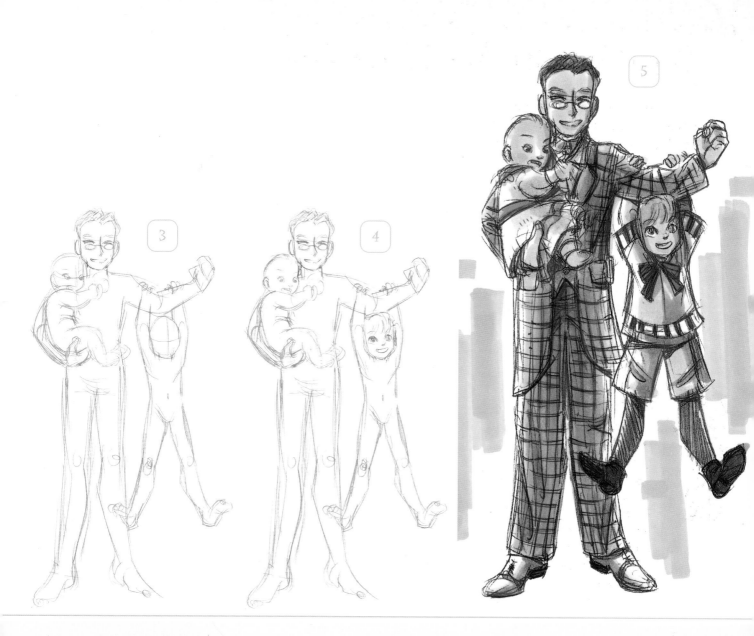

4 Draw the Brother's Face

Draw the Little Brother's eyes large, but placed like an adult's, halfway down his face. His mouth is not quite as wide as an adult's. His hair is down to his ears in a bowl cut. Give the Baby some hair.

Turn the paper over and look at all three faces. My first go at Papa gave him quite a crooked face, which is more obvious in straight-on faces than in three-quarters or profile. Correct anything "off" on the back, then add the corrections to the front.

5 Designing the Clothes

The clothes of Baby and Little Brother are based on clothes I found in a 1918 photograph. My great grand-uncle was wearing black socks and shoes, and a short pant suit with a striped sash and sleeves.

Since Little Brother is dangling, there are two creases in his shirt at the shoulders. At that time, baby boys and girls wore dresses. Papa is wearing a snappy plaid suit. The pants are cut full in the leg, with a single crease from knee to hem. His jacket falls loosely about mid-thigh. Pay special attention to the arm: besides the creases from Papa having his arm up and bent, Little Brother is making a few more with his fingers. Papa's collar is high and round, and he's wearing a collar stud in the top buttonhole. He also wears a white button-up vest between his jacket and shirt.

Mascots

A mascot is a cute sidekick character, usually an animal (but sometimes a fairy or other tiny human) that lends comic relief in a manga or anime. They may even come to the rescue, warn of danger, or react to someone with mistrust or affection. They can be counted on to have sense when their people don't, and be conveniently overlooked or dismissed by bad guys. They have baby proportions, with big heads and small bodies.

All mascots should stand about 2–2½ heads tall. Some are smaller but I find that a bit too stylized. Concentrate their features low on their heads, placing their eyes far apart, and making mouths small and ears low.

Mascot Types

You can make a mascot of anything. In Japan, an enduring character is Apanman, whose head is a piece of bread, and he's only one of hundreds of mascots based on plants or inanimate objects.

Rough Cat

Start a cat with a ball for the head, a bean shape for the body and curves for the legs. Divide the head with the construction lines to help place the features. The neck is thin; the head is wide at the jaw. The legs taper to round, delicate tip-toe feet. The eyes are large and far apart. Add the ears as wide-set round triangles.

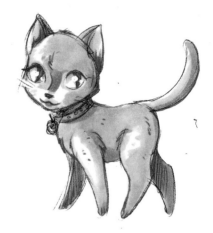

Finished Cat

I drew the pupils more like slits, but even ovals would work. Keep her outline mostly smooth, with some fluffiness at her elbow and back leg.

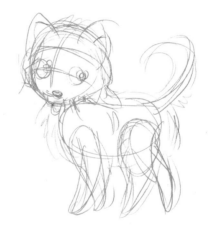

Rough Dog

The dog starts the same as the cat. The difference is a longer snout, bigger nose, and smaller eyes and ears. I've roughed in this dog's coat, which will be fluffy like a Chow, Papillon or Great Pyrenees.

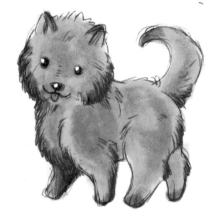

Finished Dog

The dog gets proper paws since dogs aren't slinky like cats. Keep them small. Add the eyes, nose and floppy tongue. Lots of fluffy lines for his outline does the job, since this dog is nothing but fluff. You could also take the smooth cat base, lengthen the snout, draw floppy ears and spots, and have a Dalmatian or Hound dog.

Rough Cardinal

A mascot bird is a ball on an oval, with a triangle for a beak. Draw lines for the center of the head—notice that the head is turned. Rough in placement of the eyes, wing, tail and legs.

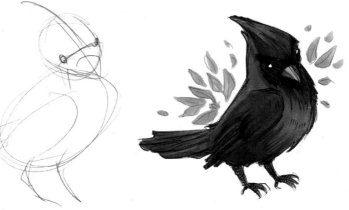

Finished Cardinal

I looked up a picture of a cardinal for this step. Exaggerate the bird's most distinctive features. A cardinal's most famous features besides its color are its black mask and crest. I also used my reference to help me get the wings, tail and feet correct.

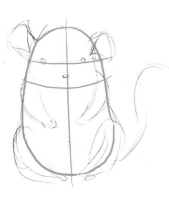

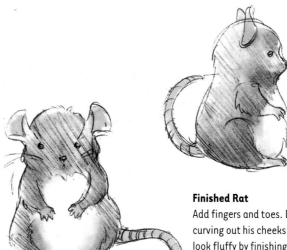

Side view

Rough Rat

This rat is a butterball with eyes. Draw a gumdrop shape and divide it down the center. Draw a line across for the head. Draw another line across the "head" a little lower than halfway to place the eyes. The bottoms of his ears are at his eyeline. Be sure to draw the inside folds. The arms and legs are banana shapes, tapering to tiny wrists and feet. Draw two dots for his eyes, experimenting to see how far apart to make them. Add the nose and a curved line for his tail.

Finished Rat

Add fingers and toes. Define his head shape by curving out his cheeks at his shoulders. Make him look fluffy by finishing his outline with soft spikes on the outside curves and on top of his head. Don't overdo the line or he'll look electrocuted. Finish by detailing the tail.

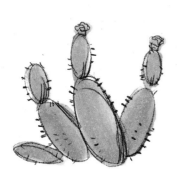

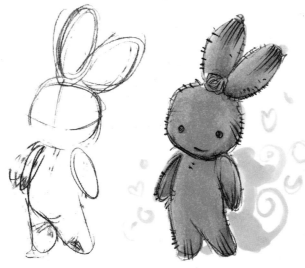

Finish

Add smooth outlines and lines sticking out for spines. Her eyes are two buttons; she has a small mouth and no nose. The flower on her head is a prickly pear flower. The tips of her ears flower, then fruit, too.

Reference Drawing

The prickly-pear cactus is the base for this mascot, Prickle. It could be used to make all sorts of standing mascots. The limit is your imagination.

Rough

Prickle's base is the female chibi. Since she's all round shapes, like the pads of the prickly pear, her legs are rounder and her arms a bit shorter. Her ears are placed on her head to suggest bunny ears.

Chibis

A Chibi (also known as super-deformed) is a small-bodied, big-headed version of a human (sometimes a robot) character. Sometimes chibis get a show all to themselves (such as *SD Gundam*), but usually characters chibi-fy for comedy, to make an acerbic comment, or have an extreme reaction. The trick to chibi-fying a character is to simplify them, then exaggerate and emphasize their most recognizable details.

Pengu-Nan
I looked at a picture of a Marconi penguin to get the colors and markings right.

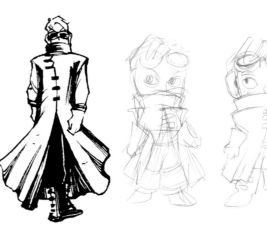

I kept Nan's hair showing so it still looks like her. Her headpiece has a beak shape and Marconi feathers.

I made Nan's suit full at her legs and arms so she looked more penguiny.

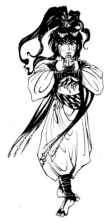
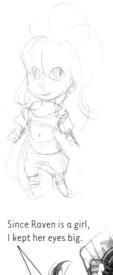

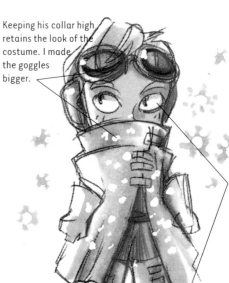

Raven
I simplified Raven's costume by keeping details like the overall shape and color, but took out rendering lines and the extra dangling parts. I also made her feet smaller so they look more "feminine."

Since Raven is a girl, I kept her eyes big.

Raven's hair is simplified to its major shapes.

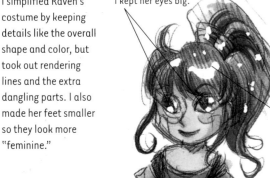
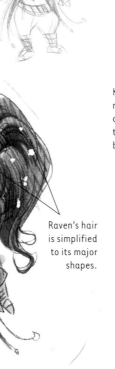

Keeping his collar high retains the look of the costume. I made the goggles bigger.

Crimson Winter
I broke Crimson down to coat, gloves, boots, and head.

I made Crimson's feet bigger and his eyes smaller than Raven's, so he reads like a guy.

Demons

Most demons are based on misshapen humans or are humanoids with bat wings and tails. I wanted a demon based on something that creeps me out: an insect—specifically, a praying mantis. Spiders and roaches bother me more, but a praying mantis also lends itself to an elegant and menacing demon, instead of one that's just disgusting.

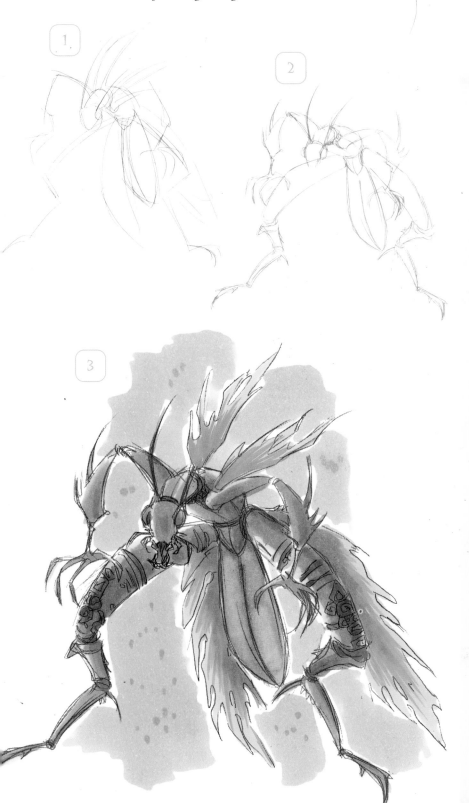

1 Sketch a Rough Shape

I looked up praying mantis pictures, and sketched some first to get an idea of where the legs, body and head go. I decided to drop one set of arms to make the lines of the demon cleaner, and to make the thigh section of the back legs longer. Start with a line that describes the way your demon is posing. I started with a curve. Sketch the positions of the arms and legs with lines; use solids for the head, neck and abdomen. Rough in the wing shapes at the shoulders and "waist."

2 Morph Him into a Demon

Flesh out the demon, keeping it slender, but don't forget that thick and thin shapes create visual interest. Make the thighs and forearms relatively thick and curve them into small joints. Draw very delicate wrists, fingers, ankles and feet, but end them in sharp points. Add spines on the forearms and legs. Refine the head and abdominal shapes.

3 Detail the Demon

A praying mantis, along with most other insects, has creepy mouth parts. Even if you stuck to them exactly, they'd be creepy enough, but add a jaw and a few more teeth for good measure. Add heavy "eyebrows" above the eyes to make them look angry and extend the antennae from them. Add tattered wings at the back and waist. I was thinking more of skeletal autumn leaves than insect wings myself, but you can experiment with sticks, bones, or rags. For the finishing touch add some tattoo-like markings on the legs. Mine are vaguely Mayan, but tribal-style tattoos would also look good.

Brutes

A classic brute is 4 heads across at his chest and shoulders. He has narrow hips, legs that are short and wide, and big arms. He is 6 heads tall because his eye line actually falls at his shoulders, suggesting no neck or that he is thrusting his head forward.

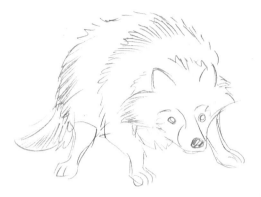

Reference Drawing
This Brute is based on a Japanese dog (the tanuki). Also known as the raccoon dog, the tanuki most often appears in cartoon form as a mischief maker, carrying a bottle of sake (Japanese wine) and unpaid bar bills. In legends, tanuki stands on the side of the road, waiting to lead unsuspecting people morally astray.

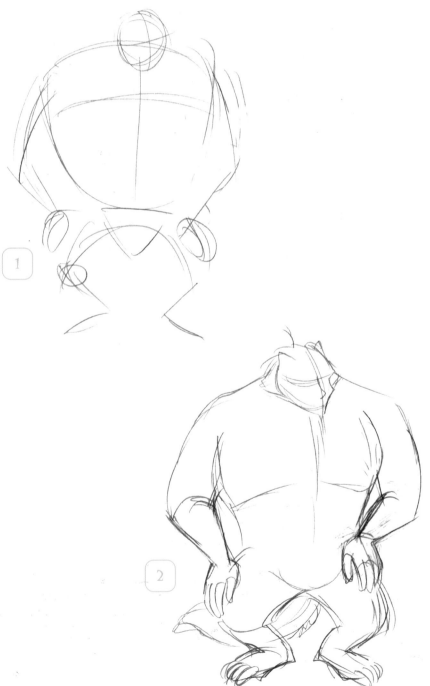

1 Design the Body
This brute is called Pry. Like the tanuki, he waits along the road to make trouble. Build the Pry's base with shapes and sticks. Give him a triangle-shaped torso and broad shoulders. Make his elbows about halfway down his torso instead of at his waist; his wrists are at his waist instead. Place his head so his eye line is at his shoulders. Bow out his legs and shape them somewhat like a dog's hind legs.

2 Fleshing Out the Body
Make him powerful-looking by drawing meaty arms, shoulders and thighs. Slope his shoulders up to his head. Pry's head is like a tanuki's, with fur projecting from the sides. Give him a pointy chin and refine his head into more of a diamond shape. He has very sharp cheekbones, which project in 3/4 view. Place small ears above his eyes, just inside the top line of his head shape. Give him large, human-shaped feet, but make his toes long and with claws. Do the same for his hands and fingers. His hands are longer than a human's. Pry holds his tail down; draw it so a little shows from behind.

3 Add the Final Details

Pry is very furry, with dark-tipped hairs like a tanuki. He also has a mask like a tanuki. Merge the human and dog form by giving him a dog nose, wide mouth and small, ferocious eyes on a sharp face. I drew him with his cheek and head hairs pulled into tassels.

Alternate Pose
Pry in a more animal-like pose and attitude, on all fours, showing his teeth and raising his back hair.

This section is on places, props, background elements, and pulling them all together.

You've studied characters, costuming, and critters.

... now you're going to see how to put them places...

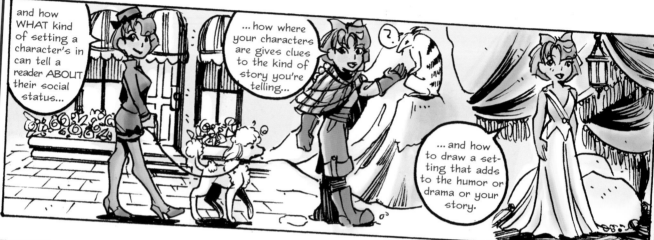

and how WHAT kind of setting a character's in can tell a reader ABOUT their social status...

... how where your characters are gives clues to the kind of story you're telling...

... and how to draw a setting that adds to the humor or drama or your story.

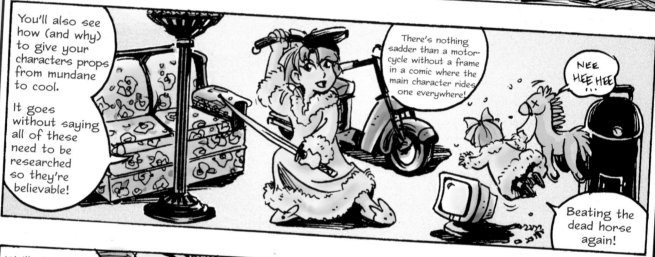

You'll also see how (and why) to give your characters props from mundane to cool.

It goes without saying all of these need to be researched so they're believable!

There's nothing sadder than a motorcycle without a frame in a comic where the main character rides one everywhere!

NEE HEE HEE...

Beating the dead horse again!

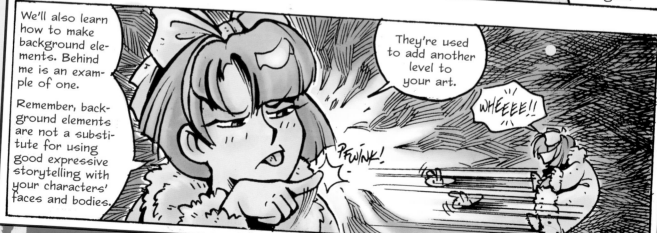

We'll also learn how to make background elements. Behind me is an example of one.

Remember, background elements are not a substitute for using good expressive storytelling with your characters' faces and bodies.

They're used to add another level to your art.

PFWINK!

WHEEEE!!

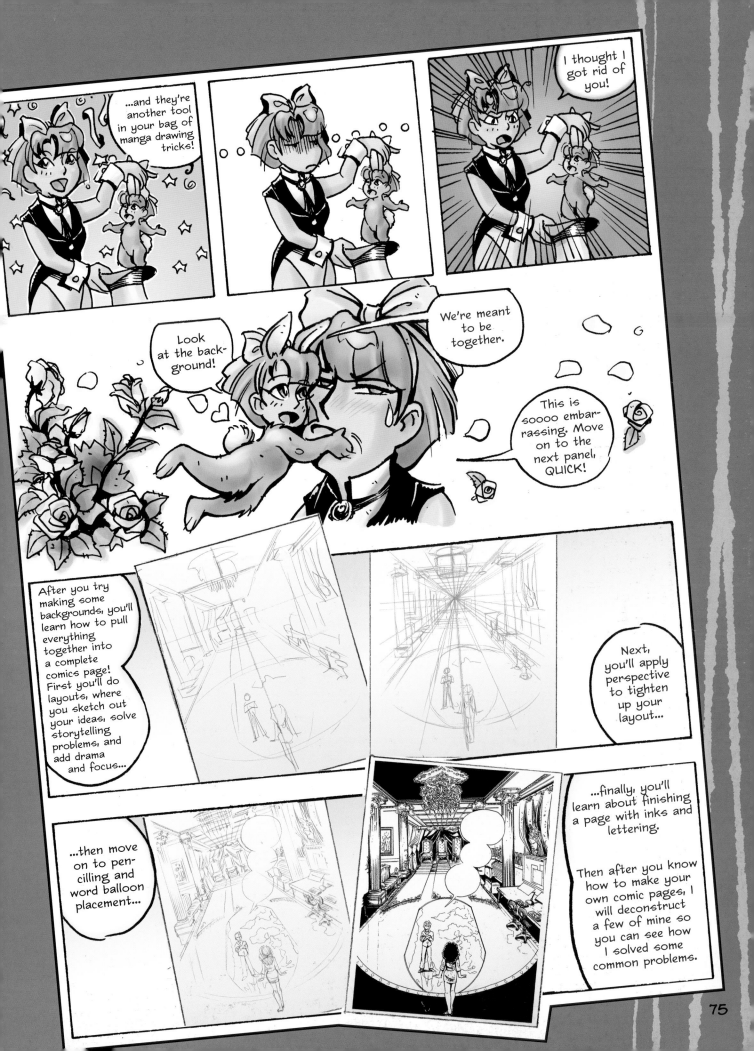

...and they're another tool in your bag of manga drawing tricks!

I thought I got rid of you!

Look at the back-ground!

We're meant to be together.

This is soooo embarrassing. Move on to the next panel, QUICK!

After you try making some backgrounds, you'll learn how to pull everything together into a complete comics page! First you'll do layouts, where you sketch out your ideas, solve storytelling problems, and add drama and focus...

Next, you'll apply perspective to tighten up your layout...

...then move on to pen-cilling and word balloon placement...

...finally, you'll learn about finishing a page with inks and lettering.

Then after you know how to make your own comic pages, I will deconstruct a few of mine so you can see how I solved some common problems.

Hard Visual Flash

Most common types of hard visual flash, especially speed, motion and zoom lines, look intimidating, but are easy to master with practice and patience. Besides adding design and directional elements to your page, hard visual flash also shows speed and shock, which is violent and sometimes humorous. There are many more types than just the ones I have listed here. By studying manga you can see how artists convey motion and emotion with these lines.

Speed Lines

These are sets of parallel lines that show speed. They usually go under the main figure or object in a scene or panel. Since they pull your eyes through a drawing, make sure they flow with your composition. Lay a sheet of paper over your drawing and draw a field of them, rotating the paper on your art to see how they'll work best.

Motion Lines

These show the direction of a person or object, or the swing of an arm or foot. They can be a few lines to describe the arc of a thrown object or the flip of a hand, or they can be taken further to suggest blurring. Motion lines are challenging because they must flow with the character, object, or composition.

Zoom Lines

These converge on a single point, like an illustration of one-point perspective (page 80). They scream "Look at this!" because they draw the eye straight to whatever is in the center of them.

Lightning

Lightning symbolizes a character's anger, shock, or dismay. You'll see it when characters are furious, butting heads, or having a shocking revelation. This effect is very labor-intensive. I recommend drawing it once and saving it on your computer for future use. Use a correction pen to create the white lines of the lightning.

The Shock

This shows that a character has been shocked by something they've seen or heard. It's a white line with a splat on the end of it, and it's almost always on a black (or dark) background. This is a far less time-consuming bit of visual flash than lightning.

Wavy Cross-Hatching

This easy but laborious effect can frame a scene or character to show someone waking up, or it can be swirled around a character to show he's feeling disoriented, nauseated, upset, or evil. It uses the principle of the moire effect—the patterns produced when you lay lines at slightly different angles over one another—to achieve its look.

Explosion With Motion and Zoom Lines

Explosions are a common visual effect you can master with practice. This demonstration also incorporates visual flash you already know: motion and zoom lines.

1 Establish the Direction

This explosion is coming from a thrown object that has left a smoke trail. Establish where the object is coming from and where it will land by sketching a trajectory and a rough shape of the explosion and smoke cloud.

2 Create the Figure

The character is throwing from a distance, so she will be small. Also draw zoom lines, and remember they radiate from a single point. Sketch the shape of a smoke trail. It starts as a motion line at Nan's head, becomes larger as it moves into the foreground, and finally becomes a wide trail of smoke. The widening lines add depth to the scene. Tighten up your cloud shape by lightly shading the shadows at the base of the explosion. Add some debris flying from it.

3 Ink or Tighten Pencils

The smoke trail is not a precise shape, so you can ink it freehand. Break up the sides of the trail with light, irregular lines, adding more and heavier ones as the trail converges with the cloud. Until you feel confident freehanding the curved lines, use a small French curve. Keep your lines light. Cross-hatch the dark shadow of the explosion cloud, darkening it as it gets closer to the ground.

Ink the zoom lines using a ruler, putting in just enough to frame the figure—don't make too many, or the scene will be too dark. Create debris by adding a few dots with a correction pen in the darkest part of the smoke.

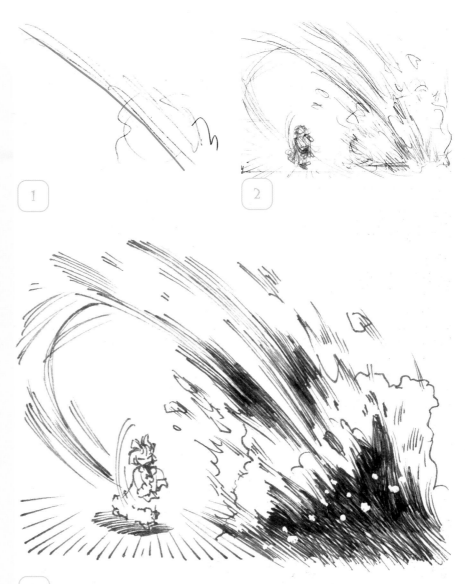

Hands vs. Computer

Much toning and visual flash can be done on the computer, with either Adobe® Photoshop® or a comic art program from Japan. The first is expensive. The second is, too, and as of this writing, there still is no English version. But if you don't have access to a computer or you're just plain not handy with one, you can simply draw your own toning and visual flash!

Soft Visual Flash

Soft visual flash suggests sadness, sweetness, or femininity. It also illustrates romance or irony and can show that a character is feeling silly or mushy. It is composed of curves, bubbles, flower petals and other characters pencilled or lightly inked with several soft lines instead of one solid one, to keep them soft and pretty.

Nothing says shojo quite like gently drifting petals. Falling petals symbolize fleeting time, transience, melancholy, romantic feelings—or all of these. Petals typically depicted are those of the cherry tree, which blooms and loses its flowers in just a few days.

To get a pleasing composition for your petals, draw a guideline first, add a sweeping curve, then place your petals on it; finish or ink them with a light line. There's also a wealth of other flowers and seeds with beautiful shapes that you create in the same way.

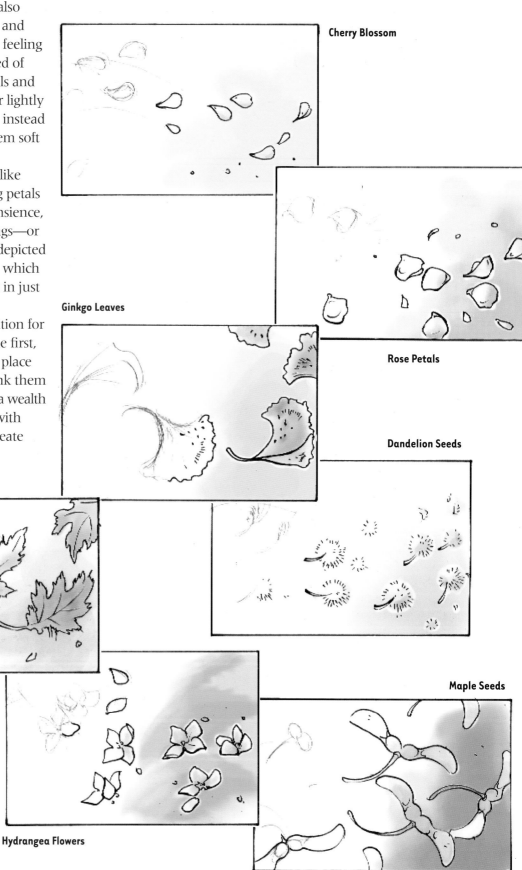

Cherry Blossom

Rose Petals

Ginkgo Leaves

Dandelion Seeds

Maple Leaves

Maple Seeds

Hydrangea Flowers

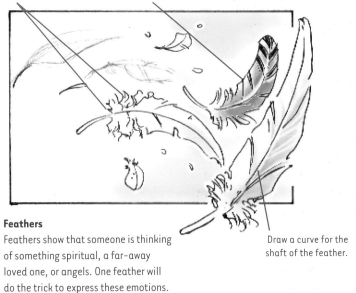

Add a few fluffy lines at the quill for softness.

Suggest barbs along the vane with light lines, but remember to ink the shapes of the vane rather than trying to ink every barb.

Draw a curve for the shaft of the feather.

Bubbles

Sketch a line for direction and flow, then add bubbles. Either freehand them or use a circle template. You can ink using the template, or pencil your circles with the template and ink over them freehand.

Feathers

Feathers show that someone is thinking of something spiritual, a far-away loved one, or angels. One feather will do the trick to express these emotions. If you draw in too many, the scene will look like a pillow fight.

Soft Lines

These work great in a scene where a character is feeling romantic or thinking sweet thoughts about someone. Sometimes they are even used for someone who feels not romantic, but utterly shattered. To create the soft-focus inking, pencil as usual, then ink using a pen about half the size you would usually ink with. Stroke light, thin lines close together. To further lighten the lines, dot on white paint or correction pen.

Flowers

A spray of flowers suddenly pops out of nowhere to frame a character—that's shojo for either the devastating attractiveness of a character, a character thinking romantic or heartfelt thoughts, or someone making fun of those feelings. Study real flowers as much as you can, pictures when you can't, and draw lots of them. Drawing flowers is like drawing hair—the shape is more important than drawing in every line. The guy is from Bali and he has inspired me to give him a tropical flower like a Bird of Paradise. I could also have used a hibiscus.

Perspective Basics

A basic working knowledge of perspective is a must-have for drawing manga. It helps you give depth to interiors, exteriors and the things inside them, like props and people. If you don't learn the basics of perspective, you'll be trapped always drawing things straight on, being frustrated with backgrounds that never look "right," or dodging background drawing completely! In this section, I give some basic instruction on using three types of linear perspective to make your scenes and props come alive. But perspective is an art all by itself, and it would take a whole book to explain it fully. Luckily someone did that: *Perspective Without Pain* by Phil Metzger (North Light Books, 1992).

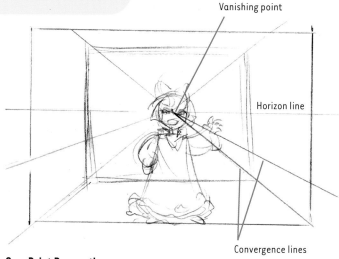

Vanishing point

Horizon line

Convergence lines

One-Point Perspective

This is the easiest type of perspective to create because all the lines intersect at one vanishing point. Looking at a scene with one-point perspective is like looking straight into an open box, or straight at a group of boxes. To create a scene in one-point perspective, establish the horizon line, then add the vanishing point to it. In this scene, everything recedes back to one vanishing point, between Nan's eyes. Use your ruler and pencil to sketch the convergence lines from the objects to the vanishing point. These lines will ensure that everything in your scene lines up correctly.

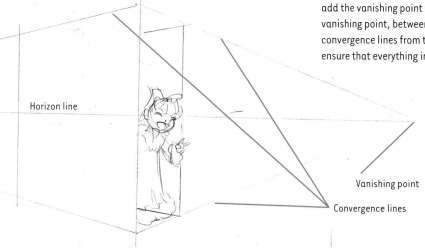

Horizon line

Vanishing point

Convergence lines

Two-Point Perspective

This allows you to create depth for two sides of an object. Objects recede to two opposite points on the horizon line instead of just one. In this example the horizon line goes through Nan's face. You can see the right vanishing piont, but the left vanishing point is out of this scene. You can put a piece of paper next to this illustration and use a ruler to extend the horizon line and convergence lines. They will eventually meet at the second vanishing point.

Perspective Vocabulary

Horizon line: The "eye-level" line, also known as the point where the earth meets the sky.

Vanishing point: The point(s) where parallel lines meet on the horizon line.

Convergence lines: Diagonal lines that recede from the object to the vanishing point.

Three-Point Perspective

Use this perspective when you are looking either down or up at a subject. This starts out like two-point perspective, but you add another vanishing point either above or below the horizon line. In this illustration, you are looking down into the scene the convergence lines are in red. Two vanishing points are above the scene, while one is below it.

Designing Everyday Props

Two things make props believable: researching and/or designing them well, and drawing them in the correct perspective. Anything man-made should be placed into perspective so it fits in the scene. The rest is details. Study real subjects as much as you can, and research the rest. Here are some examples of common objects. The red lines showing how I break them down into shapes to draw them and place them in proper perspective.

Makeup Case and Scissors

Scissors aren't easy to draw from memory. You can see the big handle because the point of view is slightly above them. Same for the makeup case: it fits into an imaginary box that you can "see" into. The design of it is made up since I wanted a case that looked like a spotted rabbit.

Clock

Based on those character clocks molded in hard plastic, this one looks kitschy and retro. You're looking slightly down on this clock, with the top of its base, the legs, the arms and the arm on the opposite side visible. The base is a slice of a cylinder.

Box of Cassette Tapes

Tapes are flat, rectangular boxes. All I had to do was look at a tape I had in my studio, and draw it over and over. I set the ones in this scene at many angles to suggest they exploded from the box when they bounced on the road. The box is linen-covered and it belonged to a meticulous, wealthy man.

Signs

I researched signs for slipping, stumbling, falling, fire, electrocution, radiation, and plain old "WATCH OUT!," and added "NO GIRLS!" I wanted the signs to look clean so I created them using Photoshop®, even though I could have freehanded them and it probably would have been faster. I placed them in proper perspective; notice how they all go slightly "uphill."

Holographic Cables

I was working out how a character would transform from a fancy costume to a fighting one, and thought "What if the fancy costume the character started in was an illusion?" which led to, "And how could they ditch the illusion in real time?" Each of these cables projects a specific part of the illusion and can be dropped, one at a time, to give the appearance of a transformation. I detailed them with the Holo-Kaz logo, like lettering you'd see on CAT-5 cable or interface ribbons. I decided the ends would be weighted to hold them in place until they were dropped or thrown.

Creating Weapons

Both swords and guns have angles where little of them show, mainly straight on, making it hard to tell what they are. In extreme foreshortening, a long blade can look as if it's short. Try to stick to angles that show the weapon's true size.

IT'S
A
DEAL.

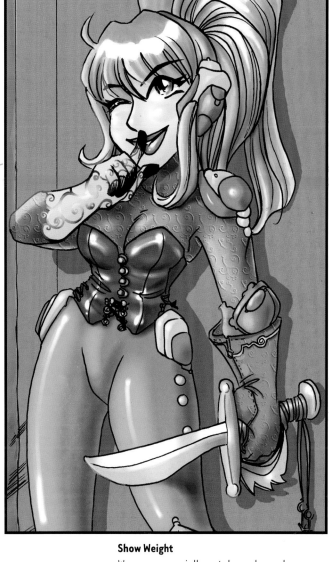

Guns

Guns come in a mind-boggling array of shapes and sizes and do jobs from personal protection to city-destroying. Most guns are a cylinder on top of an angled box. When putting them in perspective remember that like every other man-made object, they fit inside boxes that can be broken into boxes and cylinders. Remember to keep the hands holding them in perspective, too. Keep your line work on guns clean and hard, so they look metallic and shiny. Study pictures and/or replicas for details like sights, loading mechanisms, triggers, trigger guards, and so on.

Show Weight

Weapons, especially metal swords, are heavy. Make sure the character's posture reflects that. The sword that this character is holding weighs down her right arm.

Fighting Style

Weapons can tell a lot about a character's personality. Here, Nan is wielding both a frying pan and a sword. Are your character's spunky like Nan or are they more reserved? Make their choice of weaponry reflect that.

Vehicles

Vehicles are simply boxes and cylinders, in proper perspective. The work is in research, design and details. If you don't want to design from scratch, hit the library, Internet, car magazines, brochures or your own photos. Ask yourself these questions:

- Does it carry people or cargo?
- If it's people, how many and for what?
- If it's cargo, what kind?
- Is it public or private?
- Does it need a human driver?
- How does it move: gas, magic, magnets? On what: wheels, gravity, tracks? Through what: roads, water, air, dimensions?

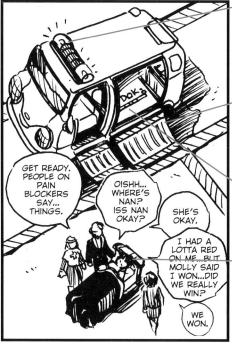

The overall design is from a VW minibus. Even in the future, flashing lights are still attention-getting.

The doors open out and down, making ramps. The ramps have caution stripes on them.

This is a one-person unit, and the gurney goes in sideways and magnetically locks to the floor.

The gurney is a self-contained unit, kind of like a *Star Trek* sick bay bed.

Emergency Vehicle
Study real emergency vehicles and see how space and equipment are used on them. What sort of technology might they have in the future?

The lines delineating the panels suggest the segments in a cicada's body.

The big window on the side is shaped and veined like a cicada's wing.

The front support of the ship is segmented and bends like an insect leg.

Little details like running lights make a "made up" ship more "real."

Cicada Spaceship
The spaceship on the cover of this book is based on a cicada.

Drawing a Car

Pretty much any car or truck can be drawn by first making a box. We'll draw my beloved Nash Metro hybrid. The steps here apply to almost any boxy vehicle, from a firetruck to a tank.

1 Create a Basic Shape
This is easy: draw a box that's in perspective. We're looking slightly down on the car.

2 Rough in the Details
Draw a line that curves inside the front end of the box to define the hood and windshield of the car. The (blue) line that makes the side extends the (red) line of the windshield. Rough in the curve of the front of the car, and place the front bumper and head-lamps. The lines of the fins sweep up so high they "break" the box at the top, but curve inside the back edge of it, too.

3 Detail Work
Tighten up all your lines and draw the headlamps, tail fin, details like the chrome on the top edge and the rocket engine tail lamps. Without going over-board, establish the darkest and lightest parts of the car. I decided to angle the line of the side windows up more to join the fins.

4 Final Details
Make your lines sharp to show a shiny and slick exterior. You can ink your curved lines with a French curve to keep them clean. Since the car is in a tunnel with a bright sign, a white band on the windshield shows the reflection. The shadow under the car is a cast shadow from the light of the sign. I broke up the shadow at the back of the car because light is behind it.

This car is the offspring of a Nash Metropolitan (1954–1961) and a 1959 Cadillac Sedan DeVille's rocket engine fins. I went for the 360-degree glass of the recent Mini Cooper, though.

There are no wheels. All the vehicles in this world work on antigravity.

School Interior

This old-fashioned classroom is in an old college building, so it has large windows, long tables and a blackboard. The script called for all the characters to be sitting together at a table.

1 Rough Sketch
This is a placid setting, so I went for a straight-on view of the classroom. The horizon line is parallel to the bottom and top panel borders, but I cropped the composition asymmetrically to make what could have been a dull straight-on view dynamic.

2 Establish Perspective
In this scene the horizon is at the teacher's eye level. Establish the vanishing point on the horizon line, then pivot your ruler around it to draw the convergence lines that radiate from the vanishing point into the scene. I added vertical lines to place the window frames, corners, chairs and characters.

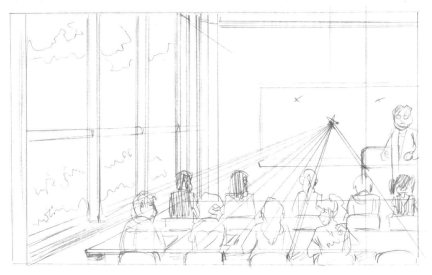

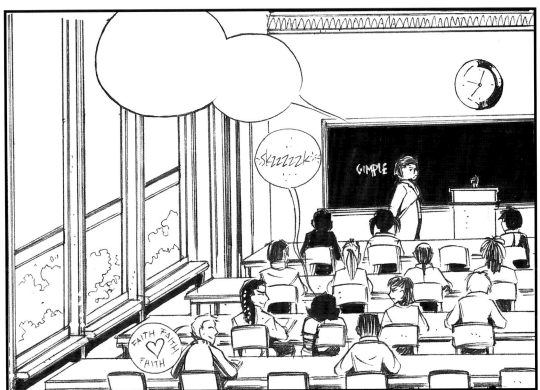

3 Tighten the Details

Draw the window frames and sills using the vertical lines you drew in step 2. Since this is an old building, they're heavy. I also designed the blackboard and podium to look old-fashioned. I spent most of the time here drawing the characters—since there are so many and each has a specific look. Notice how the characters in the front row are higher than the ones farther back. That's because your point of view is standing up looking into this room, and you're roughly the same height as the teacher. To help you draw people in scenes correctly, you can draw boxes for them. This helps to figure out how much of a person you will see in the drawing. In this scene you see more of a person sitting to the left, and only the back of someone in the middle of the room.

4 Inking

Start by filling in the blackboard, then move on to the windows. From there, ink the chairs, then the people, and then the tables, in that order so you don't have to white out any table lines. Last, ink the clouds and trees, and the design in the molding around the top of the room.

Humble Bedroom

In this scene the character lives in a microscopic dorm room. In spite of its claustrophobic dimensions, the room is stuffed, decorated and plastered with images of the object of her affection.

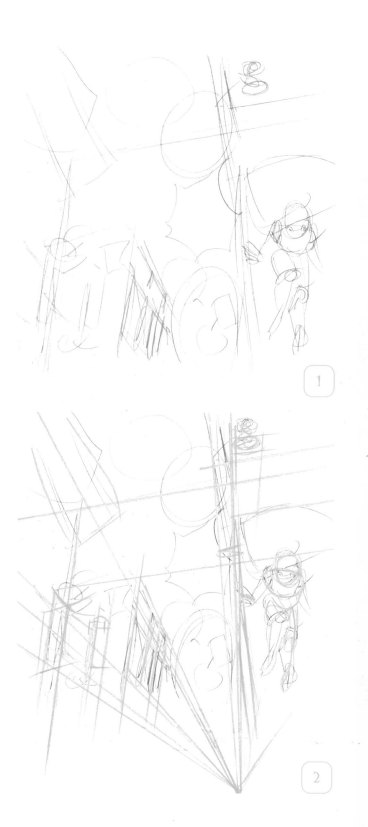

1 Rough Sketch
I wanted to create this scene at an angle that makes the viewer feel like he's been jerked backwards. So you're looking down into the room and using three-point perspective to construct it. I also roughed in the decorations.

2 Establish Perspective
This room is a box with one interior wall. I drew the line for the left-hand corner, which also gave me the angles of the desk and chair. Then I drew the interior wall edge. Those lines formed my third vanishing point. I radiated all the other lines out from that point to define the edges of the desk, chair, monitor and window. I drew a horizontal line at the character's eye line, and at 90 degrees from the most vertical of the radiating lines, which is the edge of the dividing wall. This helps me establish the perspective of the figure on the bed. I drew the vertical edges of the desk, chair, and window sill. The character is in perspective, too. Her head is the closest thing to us, so notice how it overlaps her neck. Because her right leg is up, her thigh is foreshortened.

3 Tighten the Details

Draw a clean version of the room on a new sheet of paper. Draw all the straight lines, using a ruler and the convergence lines as a guide. Remember that chair legs have depth and aren't 2-D. Also add things like the edges of shelves and window sills. Pencil the figure of the character, watching details like wrinkles in clothing that can help define her and add to the illusion of foreshortening. Tighten up the detail on small objects. The stand-up figure in the corner presented a special problem: showing a flat picture of something at an angle in 3-D space.

4 Inking

Ink more details like the baseboards, and designs on surfaces like the pillowcase and the stars on the clock. Her crush is a media star and I went crazy adding his image to the rug, mouse and doll on the desk. I could have added posters to the walls too. The trick to making an everyday room look lived-in is to put in the things that people have in them. That sounds obvious, but to do it well you have to think of how you would decorate a room if you were that character.

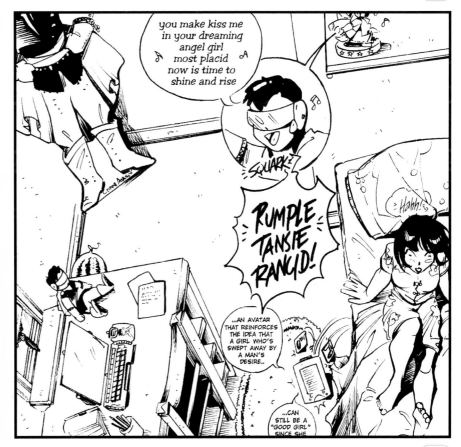

Destroyed Office

First I had to draw the office as a fairly typical work-place—then wreck it. Fortunately (or unfortunately), I've seen buildings during and after fires, and also have helped demolish a large house. If you haven't seen or made disasters close-up, you can search the Internet and libraries for photos of natural and man-made destruction.

1 Rough Sketch
The script called for a tight focus on the character as she scoots over a desk that has blown through an office window. I had to show her in relation to a copy machine and a filing cabinet, where her friend is pinned. There's a fire behind her, so I established strong light and dark patterns made by the light of the fire. A straight-on shot would have been dull and would not have shown the character in relation to her background, so I used two-point perspective. The scene gets its depth from the broken window glass and frame, with the desk and character overlapping the office's interior.

2 Establish Perspective
The first main line goes through the character's eye line. Lines parallel to that make the baseboard and the sides of the copy machine. The lines that intersect those form the remains of the front windows. The small illustration shows that this scene focuses on one area of a large office. The vertical lines also help me give the character a right-forward lean. The junked file cabinets were actually easy; I just drew boxes and tipped them in different directions.

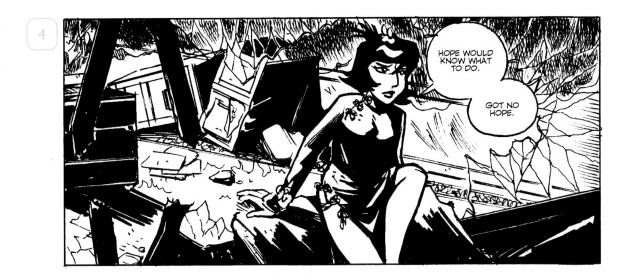

3 Tighten the Details

Lay your perspective sketch on a light table and copy the lines onto a clean sheet. The "x" indicates where solid blacks will be. I shaded in other areas to see the light/dark balance in the scene, and to keep my light source consistent. Then I detailed the filing cabinets and dented the sides. This part was a lot of fun. I also drew stray bits of paper and small fires, and sketched the outline of the smoke that is clinging to the ceiling. Draw only the largest cracks in the glass; you can do the smaller ones when you ink.

4 Inking

First I laid down all of the solid blacks with a permanent marker. The detail on the front of Faith disappears because the strong light behind her creates a silhouette. I inked Faith using a Zig pen. Nearer objects need heavier lines to make them advance in a picture, so Faith's lines are heavier than those of the objects behind her.

I inked the glass first so I could ink things behind without having their lines come through. I inked down to the last detail using a small Zig pen and a ruler. To make subjects appear darker, use more overlapping lines. Don't forget to add details like the papers, the small fires, the carpet pattern, bits of rubble, and dings and dents in everything.

Throne/Control Room

This full-page scene is of a large, well-appointed combination throne/control room. The script called for it to be a big reveal of a cavernous room full of gorgeous fixtures, and it had to dwarf the people in it. It not only has posh architectural details and furnishings, but also office furniture and high-end electronics. This is a big reveal (a moment in a story where something important is shown to the reader), the moment where the character is shown her destiny as an assassin. By placing the horizon line at a slight angle, I created visual tension and interest in a page that also needed to show a whole fabulous room.

1 Rough Sketch

This scene will be in one-point perspective. The horizon line is at an angle, and I drew a perpendicular line through that, slightly off-center. The asymmetrical composition keeps the scene from being dull. These lines meet at the vanishing point. The thrones are dead center at the far end of the room; long carpets lead to them. I also drew all the other furnishings down the sides of the space and established the two characters.

2 Establish Perspective

I pivoted my ruler around the vanishing point to draw the radiating lines that define the carpets, ceiling, edges of the pillars, and so on. I drew horizontal and vertical lines parallel to my first two lines to define pillars, stairs, heights of the chairs (to keep them consistent), and to make sure the characters are standing up straight in relation to the room.

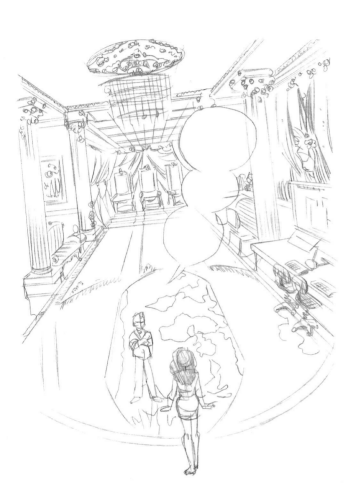

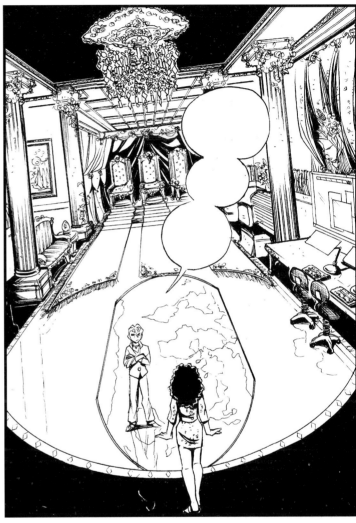

3 Tighten the Details

I pencilled the details from my previous step. The edges of the carpet and tile made a large circle on the floor, where I decided to draw a map. Instead of drawing every crystal on the chandelier at this stage, use simple vertical and horizontal lines. Pencil the accessories such as paintings, expensive office chairs, flat-panel computers and that head looming over the computers.

I pencilled the characters last. When you're putting people in a scene, they have a tendency to "lean" and get distorted. To avoid this, check what you've drawn by looking at it in a mirror or from the back on a light table.

4 Inking

I inked in as many lines as I could that needed the ruler, like the pillars, all the ceiling details, and the desks. I used my French curves for the floor details. After that, it was a lot of embellishment and details. I used solid black at the top and bottom, along the sides of the room, and behind the thrones, so that the eye goes straight toward the three empty chairs.

Mountain Road

Landscapes are some of the easiest settings to draw in perspective, since the irregular shapes of plants and terrain are forgiving. I drew this balanced rock bridge from memory. Here you'll see how overlapping elements and atmospheric perspective add depth to a scene. In this type of perspective, objects farther away in the picture have less detail and greyer overall color, as if they are obscured by haze.

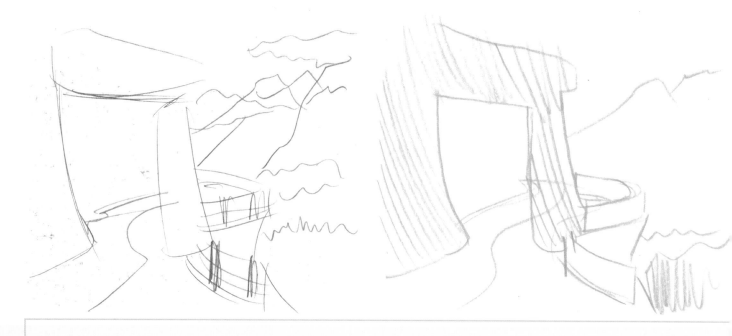

1 Rough Sketch
I wanted to show the winding road and give a sense of how high the bridge is by making it stand out against a distant background of mountains and trees. The view is fairly straight on, giving a sense of calmness.

2 Create a Diagram
I created this diagram on another sheet of paper so I could see how the composition would look. By cleaning up my pencils it is clear that: (1) The rock bridge will dominate the composition because of its shape and placement. (2) The road gives an illusion of receding because its shape tapers to a point as it goes further back in the picture. The road and the guardrail shrink as they recede.

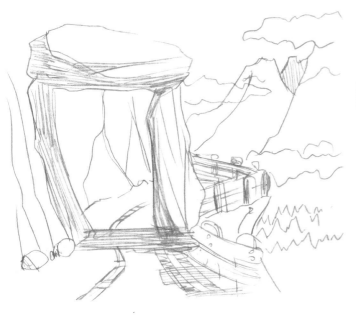

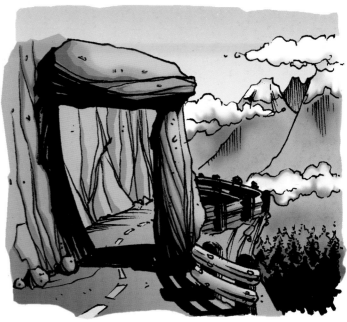

3 Tighten the Details

I laid another sheet of paper over my rough sketch and lightly pencilled the lines from it. I defined the rocks, adding lines to show wear. I refined the guardrail and made sure to make it look older, since this was a scene from my childhood. I also indicated shadows. The shadows cast by the rock bridge and guardrail across the road really make them pop. I also drew the shapes of trees, refined the mountains and added the clouds.

4 Inking and Coloring

To create the shadows under the rock bridge, I inked the pencil lines in the rocks, then filled in black so there were some light lines showing. This gives shape to the shadow. The heaviest inking should be in the foreground, to help those shapes advance. The farther back an element is, the lighter the lines get. Create interesting tree shapes made up of tiny leaves by using uneven and "broken" lines. I don't know why I rendered those vertical lines on the mountains; if I did this drawing again, I wouldn't!

Street Scene

I tried to make this panel as detailed as possible, even to the point of making each pedestrian different. If you are working for speed, keep backgrounds minimal and rely on establishing shots to place your characters in the reader's mind. Those shots must be as detailed as possible. The panel before this had a lot of talking heads, which I wanted to break up. I also needed to show where a character was going and by what means, rather than having them say so. I wanted the scene to show a teleporting station for vehicles and people.

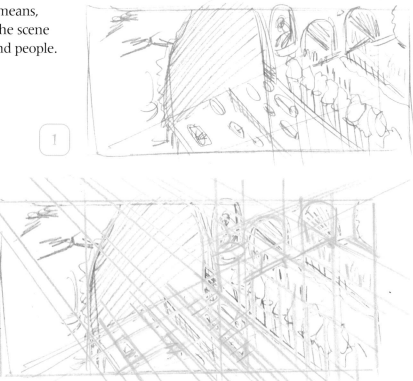

1 Rough Sketch
The aerial view creates visual interest and shows the entrance and exit lanes. I also drew some birds. Notice that I scribbled to establish which areas are going to be black in the final art.

2 Establish Perspective
This scene is in three-point perspective. The point of view is looking down into the corner of a box. The two top vanishing points run off to the left and right. Notice in the diagram how the left-hand lines were beginning to converge. The way to make sure your lines diverge correctly is to pick the vanishing point, and pivot your ruler on that. Draw as many of these radiating lines as you think you'll need. You're not going to have to erase them, since you'll be transferring your drawing onto a fresh sheet of paper. I also drew vertical lines to establish the sides of the tunnels, rails, tree trunks and people.

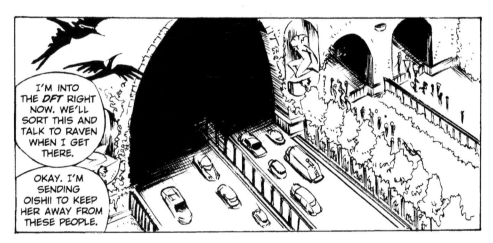

3 Tighten the Details

I pencilled the scene by laying a new sheet of paper over the one covered in convergence lines and used my rough as a guide. Notice how each vehicle fits inside a box made by the intersection of lines. I wanted this to be an ideal vehicle and pedestrian-friendly thoroughfare, so I've included trees to separate vehicle and pedestrian lanes, lots of oxygen-making greenery, wide footpaths and decorative elements like the Mercury statues (god of speed—get it?).

4 Inking

Lay down the black areas with a permanent marker. (This is one of my secrets to jump-start inking.) Then ink in all the lines that need a ruler, like the railings, using a Zig pen. After that, add everything organic, such as trees and people. Freehand the tunnels to keep them soft-looking. The last step in inking is to add decorative and/or shading lines. Shade the tunnels by hatching, giving the impression of a soft edge to the absolute darkness.

Futuristic City

This is an establishing shot of a penthouse apartment in a densely-built city. It's another one of those shots where I went with a lot of detail to strongly place my character in the reader's mind.

1 Rough Sketch

I wanted the composition to have tension and visual interest because it's the beginning of a sequence that depicts a character in distress. I started by drawing a vertical and a horizontal angled line through the panel, and roughing in the buildings on the sides of them. I wanted a downward angle, to show as much of the city as possible without losing the focus on the foreground building, and to get the character close to the top of the panel.

2 Establish Perspective

This scene is in two-point perspective, but it doesn't use convergence lines, because not enough is shown to see the convergence. Using the ruler, I drew vertical lines perpendicular to the horizontal line I established in step 1, then added the (non-receding) intersecting horizontal lines, using the rough lines of the buildings from step 1. This makes a bunch of boxes of various shapes and sizes. Notice how intersecting lines create angles that point down. I also roughed in the shapes of two bridges.

3 Tighten Details

This was the most labor-intensive part of the scene because there were so many precise architectural details. I pencilled very, very tight, cleanly and with a lot of detail, to save myself inking time. I was planning on showing the traffic on the distant bridge, rather than the bridge itself, so the "x" reminds me that the vehicles and lights go there. I also pencilled the apartment interior, making sure enough of the character was visible.

4 Inking and Coloring

This step was easier than the previous ones but it still took almost as much time. I laid in the sky with permanent marker, leaving the white lines of the bridge to fill in later. Then I inked the buildings, starting with the nearest one, using my ruler and a Zig pen. Notice how I left space between the outlines of the buildings; this makes them pop.

Once I inked all the straight lines, I added details like plants, the roof, gargoyles, the interior of the apartment and the character; I also hatched in the building sides. I filled in the white lines of the distant bridge. I forgot to leave the light poles uninked, so I put them back in using a fine-tip white ink pen.

Creating a Comics Page

Follow the directions on the next four pages to create your own comic pages.

1 Working With a Script

You can either start creating a comics panel directly from a script or let the layout be your script. There are many ways to make manga, as well as to script it. Find out what works best for you. I prefer to write a script with descriptions of where characters are moving, what they are wearing, where they are, their expressions and all the dialogue. I use that as a guide to laying out pages. You can also write a script and lay out pages on the same sheet, at the same time.

2 Create a Layout

A layout is where you begin to work out solutions for your final page. Decide the number of panels a page needs. If the page introduces a new scene, establish the setting. An establishing shot doesn't have to be huge, but it does have to clearly show the scene. Here are other things you should be thinking about at this stage:

• Get your characters acting out the scene.

Script Source

To see scripts other people have worked from, or written/drawn, check out *Panel One: Comics Scripts by Top Writers* and *Panel Two: More Comic Book Scripts by Top Writers*, both edited by Nat Gertler and published by About Comics.

Script

Rumble Girls: Silky Warrior Tansie
Part 5, page 3

Panel 1 Shows who's in the scene: Raven.

Panel 2 A long shot shows both characters. Their body language is of two friends holding their arms out to each other.

Panels 3-5 A progression of emotion for Raven, from happy to choking up to crying.

Panel 6 A small panel. Raven is sitting on the floor, snuggled into the side of Nan. She's still eating something, and empty food containers are strewn around her.

Panel 7 A close-up because she's saying something very important.

Panel 8 Butterflies make a transitional element.

BUTTERFLIES

Layout

Using cheap paper I rule off a 6 ¾" × 10" (17cm × 25cm) area, the typical size of an American comic book. Inside this area, I draw another box, leaving ½" (1cm) on all sides for bleed. It keeps word balloons or important bits of art contained. The reason why the last panel says "BUTTERFLIES" is because I was reusing an image of butterflies as a transitional element.

- Capture their body language, expressions and where they are in relation to the setting.
- Establish perspective.
- Decide what the most important panel on the page will be.
- Establish placement of word balloons.
- Decide what doesn't work, like too many panels that show the same angle and distance, or don't show important details, or just plain bug you. Re-think and re-draw them.
- Try to have at least one panel per page that's fun to draw. This is especially important to keep yourself motivated on a long project.

3 Panels and Word Balloons

After you have your rough layout, it's time to start creating a template for your pencils. In this stage you establish the gutters between the panels and draw the word balloons. To help you decide balloon sizes, write your dialogue as close as possible to the size you'll be lettering it.

4 Pencilling

Pencilling is the time to finish solving problems in anatomy and perspective and to add most of the details.

Breaking Panels, Drawing Word Balloons
Tape your layout to the back of the paper you'll use for pencilling. Trace the boxes from the layout, making sure they're square, with a ruler and light table (or window). Mark where your page is divided into horizontal tiers. Make a second mark about $^3/_{16}$" (5mm) below the first one, and make marks in the same place on the opposite side of the page; connect them to make gutters. Do this for all your horizontal gutters. Mark your vertical gutters the same way, but make them about half as wide. Sketch in your word balloon shapes.

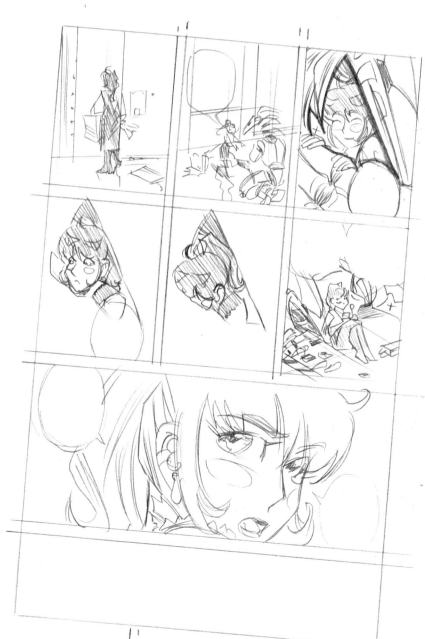

Pencils
With the layout still taped to the back of your paper, mark off convergence lines. After that, pencil, using your layout as a guide. Correct and change as needed.

I make my pencils very tight, so I can ink fast. Turn over the pages you are pencilling often to check them from the back for skewed faces and perspective. Correct any problems on the back, then flip the page back, erase where you corrected and re-pencil.

5 Inking

This is where your comic comes together. Tape your pencils to the back of your inking paper or bristol board and lay that on a light table or window. Once the page is inked, go back and correct anything that bugs you. Fix minor things with a correction pen, and draw over that when it's dry.

6 Lettering

I scan in the page and letter it in Photoshop®. Scanning and lettering are a whole book unto themselves; however, a great site with good-looking free fonts and tips on scanning and lettering is Nate Piekos' Blambot Comic Fonts and Lettering at www.blambot.com. There's also www.balloontales.com, with instruction from award-winning comic book letterers.

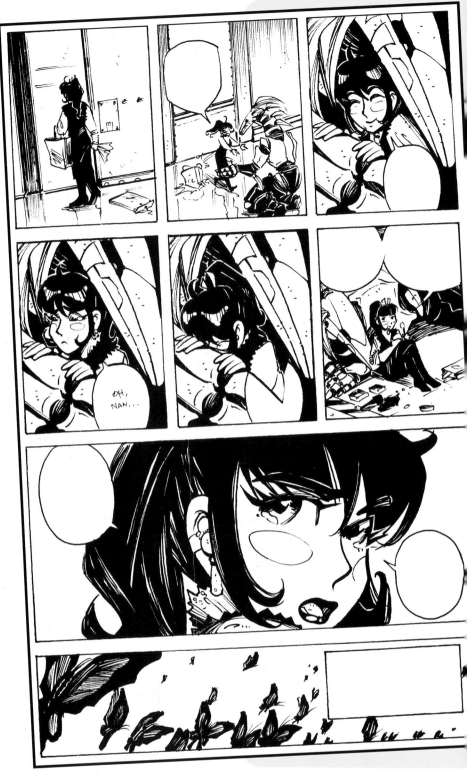

Redrawing Panels

If there's a panel that's just not working or got overdone in inking, don't be afraid to draw a new one and cover up the old one. I've found I spend more time trying to save a panel that stinks, rather than just starting over. Before you redraw, however, take a break from the page. You may decide it's not so bad, and you'll have saved yourself a hassle.

Inking

Using an inking tool and ruler, ink your panel borders first. Don't draw in the spaces between the gutters because they're a pain to fix later. Next, ink the word balloons. For the long shots, I inked with a small pen and a light line to keep the small details clear and tight. In the extreme close-up, I used a larger pen. For her hair, I inked the lines first, then filled in between them with black, leaving the lines white to help define her hair shape.

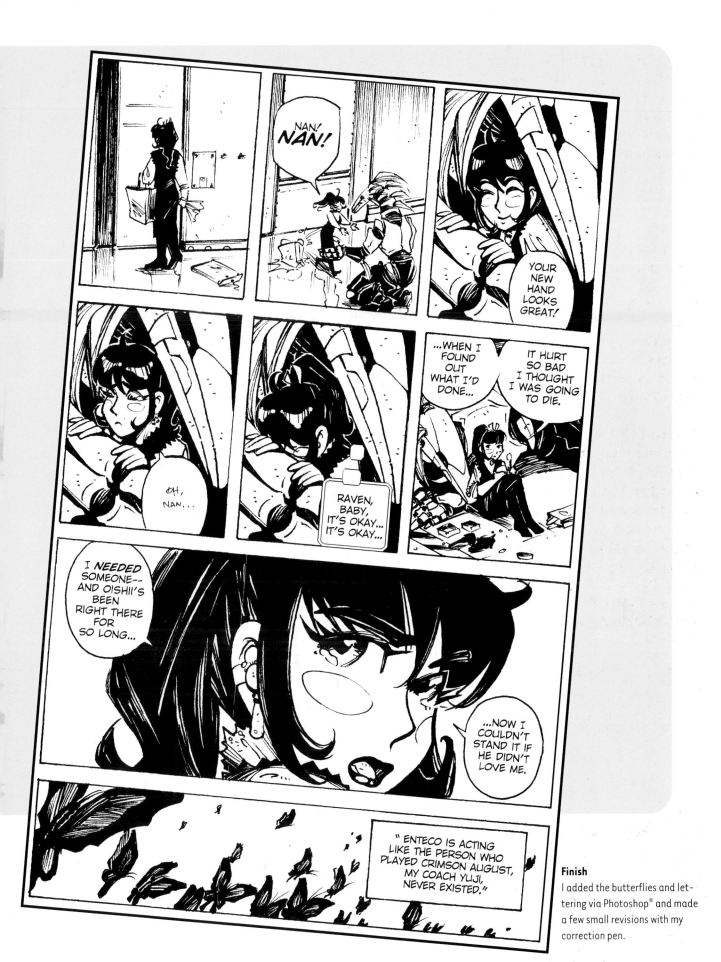

Finish
I added the butterflies and lettering via Photoshop® and made a few small revisions with my correction pen.

Making Dialog Flow

This page shows good examples of architecture and rendering in the establishing shot and shows how to break up dialogue in thought balloons to create interesting panels. I wanted the establishing shot to show where the action is taking place—Raven's posh new apartment. Seven panels of dialogue follow to keep the page flowing. The challenge was to make those panels interesting.

Panel 1
I chose this angle not only for its interest, but also so that I could frame Raven, seen through her window at the top. Her high apartment, while it shows she's rich, is also a metaphor for her isolation. She's literally a princess in a tower.

The faraway traffic is shown by mere dots of white indicating headlamps of cars and street lights.

A very thin, subtle outline here makes Raven's building "pop" away from the background.

I used a variety of building styles here. I was thinking of a heavily developed city like San Francisco, where every downtown building is different from every other.

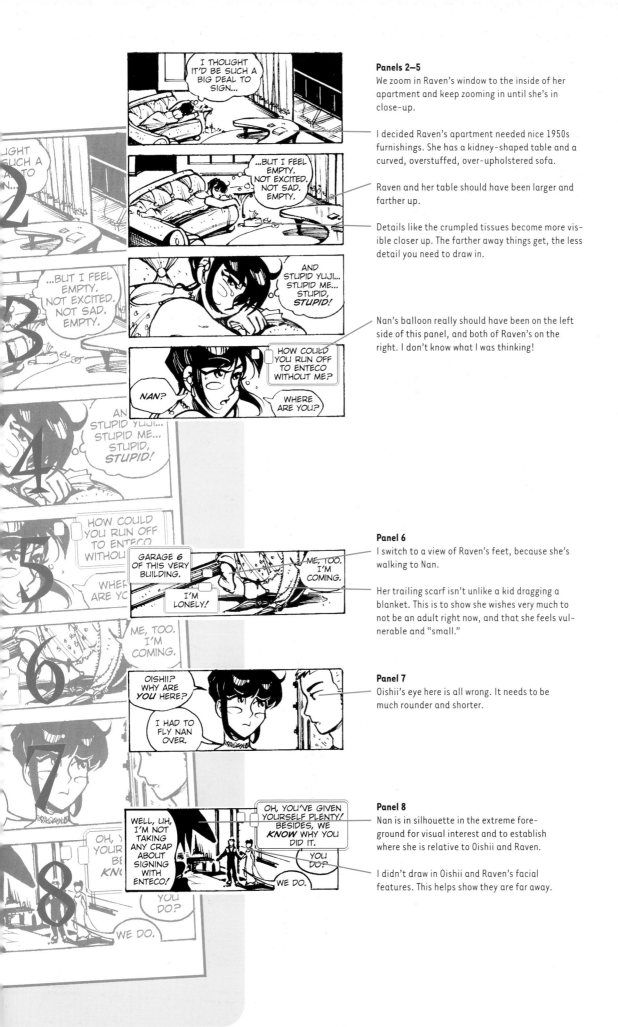

Panels 2–5

We zoom in Raven's window to the inside of her apartment and keep zooming in until she's in close-up.

I decided Raven's apartment needed nice 1950s furnishings. She has a kidney-shaped table and a curved, overstuffed, over-upholstered sofa.

Raven and her table should have been larger and farther up.

Details like the crumpled tissues become more visible closer up. The farther away things get, the less detail you need to draw in.

Nan's balloon really should have been on the left side of this panel, and both of Raven's on the right. I don't know what I was thinking!

Panel 6

I switch to a view of Raven's feet, because she's walking to Nan.

Her trailing scarf isn't unlike a kid dragging a blanket. This is to show she wishes very much to not be an adult right now, and that she feels vulnerable and "small."

Panel 7

Oishii's eye here is all wrong. It needs to be much rounder and shorter.

Panel 8

Nan is in silhouette in the extreme foreground for visual interest and to establish where she is relative to Oishii and Raven.

I didn't draw in Oishii and Raven's facial features. This helps show they are far away.

Illustrating an Action Scene

This page shows a natural exterior, a bit of posh interior and action and visual flash in the form of force lines and motion lines. This scene takes place as part of a televised show so I composed the action within regular four-panel pages framed with black to suggest it was being viewed on some sort of wide-screen TV. In this page, Raven is confronting her nemesis, Carmen Cameron, and is about to gain the upper hand in their fight. I re-drew panels 2–4 from what they originally were after I had learned a lot about drawing action. It's still problematic, but not awful.

Panel 1

Raven's skull is too small, and her eye is too long!

The clouds make a nice simple background but they're a cheat; if I'd used correct perspective, the background should have been the hills seen in panel 2, but they were distracting.

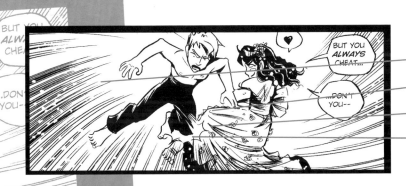

Panel 2

It might have been better to see Raven's profile here.

Foreshortening shows that Carmen is leaping at Raven.

The balloon should have been lower.

The reflection in the floor helps add depth. I cheated by not adding reflections of the rails and hills. They made the panel too busy.

Panel 3

The force lines emphasize Carmen's leap.

They also emphasize Raven's knee coming up.

And they carry through the folds in her skirts.

This shows that Raven's shin has contacted with Carmen's leg.

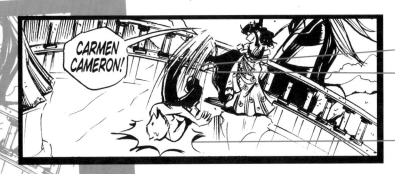

Panel 4

Motion lines show the direction of Carmen's fall.

Raven's foot is still in the air and shows how high she pulled her leg to trip Carmen. Showing follow-through in action sequences is important so that the action is clear to the reader.

The splat shows that Carmen has fallen hard.

Solving a Storytelling Problem

This page shows a completely different rendering technique: pencils instead of my usual inks. It demonstrates some very subtle visual flash, some very flashy visual flash, and a solution for a difficult storytelling problem.

This page was part of a long fight sequence between Carmen and Raven that takes place in a holographic arena. They are both wearing holographic costumes they can manipulate on command. I decided the sequence needed a soft, dreamy feel to play up the unreality of it, and to help distinguish the fight sequence from scenes within the fight sequence that took place in control rooms. The idea was to make the fight visually distinct so readers would be able to figure out what was the fight and what was happening behind the scenes of the fight.

Panel 1

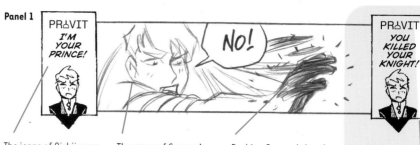

The icons of Oishii were dropped in using Photoshop®. There were many scenes in *Rumble Girls* where characters talked on something like Instant Messenger. The icons let the reader know who's talking.

The curve of Carmen's high collar overlaps her face, giving the panel depth.

Pushing Carmen's hand to the extreme foreground puts the focus on it as it begins to turn black, showing that she's losing the fight with Raven.

The lines around her hand draw attention to it.

Panel 2

The burst balloon with the large hand-lettered "NOOO!" shows Carmen is distressed.

A white line around the foreground elements would have made them stand out more.

That is Carmen, oh-so-teeny in the background. This would've worked better if I'd made her a silhouette.

The angle of the HardSkin's fingers do give a nice visual tension to the panel.

Panel 3

Making Carmen's dialogue tiny shows she's losing her voice with fear.

Carmen is framed in the closing doors of her HardSkin to focus the eye on her expression.

Panel 4

Overlapping Raven's shoulder as she bends forward gives the panel depth.

The bits of clothing and snapping vines going in the opposite direction of Raven's body lend visual tension and movement.

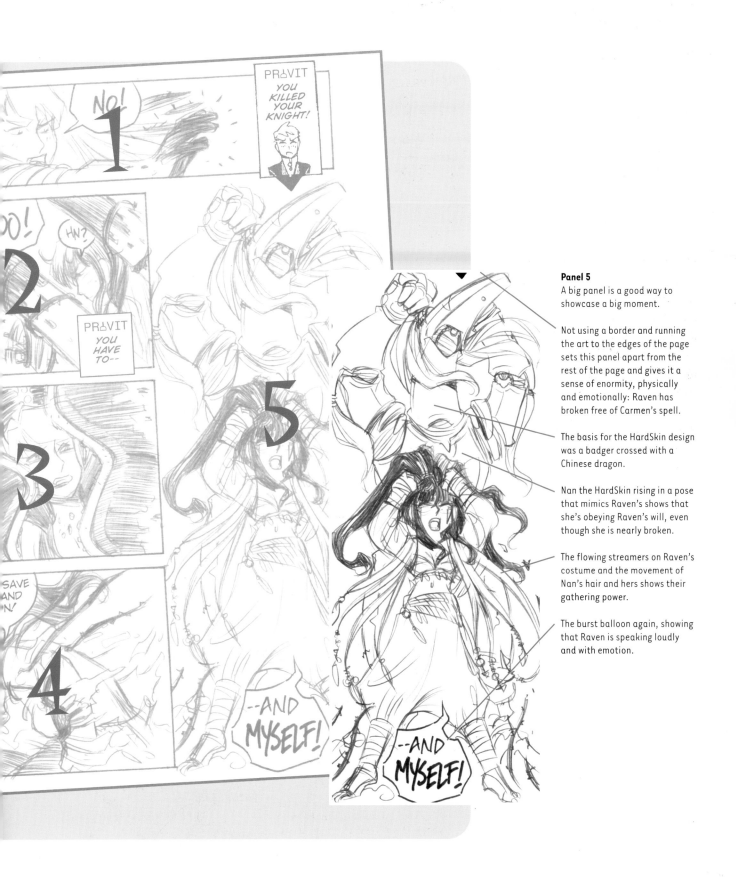

Panel 5
A big panel is a good way to showcase a big moment.

Not using a border and running the art to the edges of the page sets this panel apart from the rest of the page and gives it a sense of enormity, physically and emotionally: Raven has broken free of Carmen's spell.

The basis for the HardSkin design was a badger crossed with a Chinese dragon.

Nan the HardSkin rising in a pose that mimics Raven's shows that she's obeying Raven's will, even though she is nearly broken.

The flowing streamers on Raven's costume and the movement of Nan's hair and hers shows their gathering power.

The burst balloon again, showing that Raven is speaking loudly and with emotion.

Practice everywhere: parks, airplanes, restaurants, sometimes even at home.

It's like walking a dog wearing a bandanna: you'll get lots of attention!

Taking one on an airplane will do that, too!

And, one day, THIS will be the attention you command.

But ONLY if you PRACTICE.

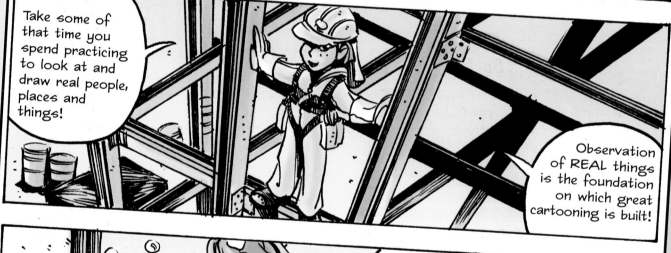

Take some of that time you spend practicing to look at and draw real people, places and things!

Observation of REAL things is the foundation on which great cartooning is built!

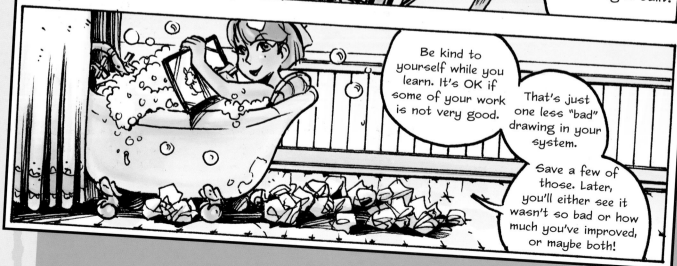

Be kind to yourself while you learn. It's OK if some of your work is not very good.

That's just one less "bad" drawing in your system.

Save a few of those. Later, you'll either see it wasn't so bad or how much you've improved, or maybe both!

110

Index

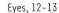

Good Books

MANGA! MANGA! THE WORLD OF JAPANESE COMICS by Frederik L. Schodt
ISBN 0-87011-549-9

DREAMLAND JAPAN: WRITINGS ON MODERN MANGA by Frederik L. Schodt
ISBN 1-88065-623-x

THE ANIME ENCYCLOPEDIA: A GUIDE TO JAPANESE ANIMATION SINCE 1917 by Jonathan Clements and Helen McCarthy
ISBN 1-88065-664-7

THE ANIME COMPANION: WHAT'S JAPANESE IN JAPANESE ANIMATION? by Gilles Poitras
ISBN 1-88065-632-9

SAMURAI FROM OUTER SPACE: UNDERSTANDING JAPANESE ANIMATION by Antonio Levi
ISBN 0-81269-332-9